BARRON'S ART HANDBOOKS

BAROQUE PAINTING

BAROQUE PAINTING

BARRON'S

CONTENTS

INTRODUCTION

The taste for Greco-Roman Classical aesthetics, developed during the Renaissance (Quatrocento and Cinquecento), including the Mannerism of Titian and Tintoretto, led at the beginning of the seventeenth century to art less focused on Classicism. It did not consider "form" its supreme objective. This new set of aesthetics saw formal beauty not only as an end but as a way of conveying emotions, achieved by dramatizing expression and exalting movement. By the last decade of the sixteenth century and the beginning of the seventeenth century, European art had become theatrical with exaggerated gestures and expressions, a passion for deformity, and, as a decorative aspect, the abhorrence of open spaces.

These basic characteristics, which appeared and were further developed in Europe during the seventeenth and eighteenth centuries, coincided with one of the greatest epochs of painting. Baroque painting spans a wide range of tendencies, from Carravaggio´s tenebrist realism (early seventeenth century) to the enormous fresco paintings whose allegoric scenes adorn the walls, domes, and ceilings of temples and palaces built during that time. The immensity of the compositions, containing countless figures and superlative architecture that transcend their real limits, mark the most expressive representative part of the Baroque, which closed the eighteenth century with the genius and virtuosity of Tiépolo and the subtleties of Rococo. During the Baroque period, Europe experienced one of the most dynamic and creative periods of universal painting.

It is important to differentiate between the European period we define as the Baroque and the specific artistic manifestation of any time and any culture.

This book examines the European style and painters of the Baroque period in as much depth and extension as a publication of this type allows. We are consequently aware that many Baroque works of art, as well as artists, will be missing. Art history of the seventeenth and eighteenth centuries, when it wants to (or can) be thorough, must contemplate perhaps like in no other period, an interminable group of fine artists, the masters of the art of painting. And as such—as in our case, it is of the utmost importance to be selective—once the most indisputable artists have been selected, the dilemma arises as to which ones, among the rest, have best represented a specific school or tendency and which ones can be omitted. The reader should bear in mind the diversity of criteria that can influence such a decision and, therefore, it is inevitable that everyone´s taste cannot be satisfied.

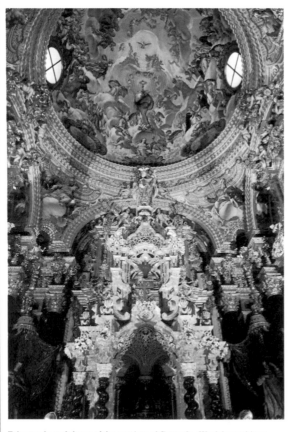

Tabernacle and dome of the sacriste of Granada. *Work by architect Francisco Hurtado (1669–1725), with fresco by Antonio Acisclo Palomino (1653–1726). We have selected this work to exemplify "the abhorrence of open space" so characteristic of decorativeness of the Baroque. It also provides us with an excellent example of its extraordinary capacity of merging together into a single creative idea, the so-called drawing arts: architecture, painting, and sculpture.*

Baroque Art and Its Circumstance

Baroque art is a prolongation of the Renaissance. In fact, Baroque artists used the same creative elements as those employed during that period, but intensified and combined in such a fashion that they achieved another type of literature, music, or painting. *In other words: they spoke in Baroque using the vocabulary of the Renaissance.*

The Baroque represented a new form of literary and creative communication, capable of providing an answer to the culture and power of the ruling classes that surrounded the absolute monarchies and the Catholic church (in Italy, Spain, Flanders, and France) and the Protestant churches, in England and Holland, as well as in the Scandinavian and Germanic countries.

It can be said that the transition from the Renaissance to the Baroque is marked by one of the most tense periods in

European history, when religious feelings and beliefs were being passionately debated, combined with the interests of the increasingly authoritarian monarchies and those of the Catholic Church and the other new Christian denominations. Around the middle of the seventeenth century, Europe was plunged into a series of religious wars, known together as the Thirty Years War (1618–1648). It was a period when, beside the development of humanism and the emergence of science, Europe was carved up into two opposing religions: countries that remained faithful to Catholicism and those that espoused the Protestant confession. This division had a profound effect on the development of Baroque art in countries of either religion.

As we mentioned earlier, Baroque art originated in Italy, zealously protected by the Catholic religion, which exploited it (especially in its plastic form) to the utmost as an

excellent propaganda tool in order to thwart Protestant Reform after the Council of Trent (1545–1563) had definitively laid the foundations for the restoration of Catholicism.

By the seventeenth century, when Rome appeared to have defeated Calvinist heresy, the Catholic Church manifested its self-proclaimed victory by means of triumphant artwork, by exalting the figure of the pope and the beliefs that had been considered dogma by the Council of Trent.

These artistic winds of change reached other European countries, influencing aesthetic ideologies in a wide variety of forms. Baroque art in Protestant countries responded to different motivations than those of Catholic countries. In the countries unaligned with Rome, especially in Holland, the rise of a powerful bourgeoisie, capable of creating an art market independent of ecclesiastical and political power, was decisive.

François Girardon Monument to Richelieu (between 1675 and 1677), Sorbonne Church, Paris. French Baroque sculpture is obsessed with the dynamism of forms. The extremely dense drapery barely allows the existence of a flat surface or a straight line. This extraordinary funerary monument is, in addition to other considerations, a technical prowess, since no matter what position it is viewed from, the seemingly infinite number of folds are seen as continuous rhythms.

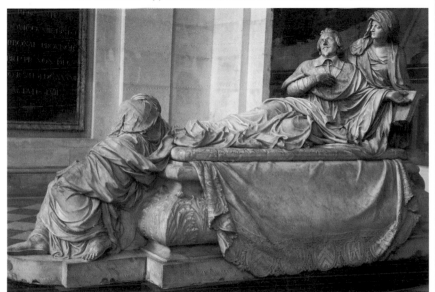

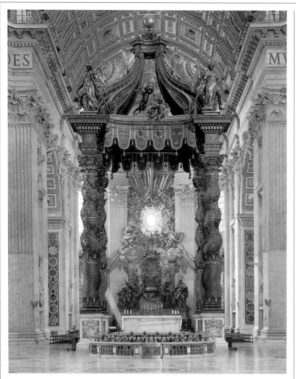

Giovanni Lorenzo Bernini. Baldachin of St. Peter's Basilica, Rome *(1624–1633). The great Baroque architect (1594–1680) summarized in this baldachin (an architectural and colossal sculpture at the same time), all the Baroque "liberties": columns with twisting and profusely decorated shafts, fantastically clad Corinthian capitals, curved entablatures, capricious volutes, and so on—a work that reflects the power and wealth of the church during the Counter-Reformation.*

language that expressed its triumph; sculptures used this language to create images of great eloquence. On occasions the chosen motifs were male nudes (with exaggerated, muscular bodies) while on others, they represented bodies just discernible under the folds of their draperies. A fine example is *The Ecstasy of Saint Theresa* by Bernini.

Painting

We have chosen to introduce a book dedicated entirely to Baroque painting by describing the architectural and sculptural forms of the same historical period because architecture and sculpture are the plastic arts that best exemplify the characteristics of what we nowadays unwavingly classify as Baroque.

Even for a person unversed in art, the *Baldachin of St. Peter's Basilica* (a work by Bernini) and the *Monument to Richelieu*, by the Frenchman Girardon, for example, are easily identifiable as Baroque works. The spectator immediately recognizes the tendency toward using twisted ornamental forms (as is the case of the baldachin), while in the sculpture, we see the dynamic composition (it contains virtually no straight lines) used to enhance the dramatism of the movements and the numerous folds in the draperies.

The painting of this period, however, does not always display these Baroque features. During the Baroque period, Italy, France, Spain, Flanders, Holland, and England developed pictorial schools that had their own personalities (which does not preclude mutual influence), ranging from realistic to visionary postures, including also Classicist painters. The expression *Baroque painting* does not refer to a uniform style whatsoever. The great painters who worked during the Baroque period reflected, in their own styles, the changes their respective countries were undergoing under the influence of the religious, political, and cultural upheaval described earlier.

Baroque Forms

Architecture

The forms used by the Baroque architect were not the result of his creating new elements. These Baroque forms arose from lending an ornamental value and function to elements that, during Classicism and the Renaissance, served a purely constructive purpose. During the Baroque period, columns, capitals, entablatures, friezes, and pediments were used not only as architectural but also as ornamental elements, to the extent of concealing their original purpose.

During the Baroque period, art took on a grandiloquent tone, as did architectural elements accordingly. Columns twist around their axis, entablatures are broken up into bolections, and the acanthuses of the Corinthian capitals seem to flutter in the breeze.

Sculpture

Sculpture is also a good example of Baroque's grandiloquent style. It is, undoubtedly, the art that best epitomizes the excesses of the Baroque style. In sculpture, the movement of the human body, its writhing and extreme expression, together with the exuberance of the decorative and architectural elements, plainly reveal the tragic and pompous dramatism so characteristic of the Baroque.

We already mentioned that Italy, the birthplace of the Renaissance, was also, thanks to the patronage of the Catholic Church, the creator of an artistic

Summary 9
Introduction
On the Threshold of the Baroque. Caravaggio

The aim of this book is to offer the reader an overview, almost an anthology, of the works of the most representative artists of Baroque painting in Italy, France, Spain, Flanders, Holland, and England, within the context of the painter's life and the historical circumstances that shaped European societies during the seventeenth and eighteenth centuries. We trust we have fulfilled this aim.

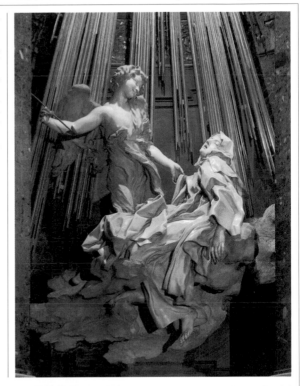

Giovanni Lorenzo Bernini,
The Ecstasy of Saint Theresa
(1644–1652), Cornaro Chapel,
Santa Maria della Vittoria, Rome.
One of the seventeenth-century
works of art that best expresses
the passionate Baroque dynamism
used to give form to a catholicism
both mystic and triumphant.
Bernini, an architect and sculptor,
was one of the Baroque artists who
best expressed the dominance of
passionate sentimentalism over
the formal deliberation of
Renaissance Classicism.

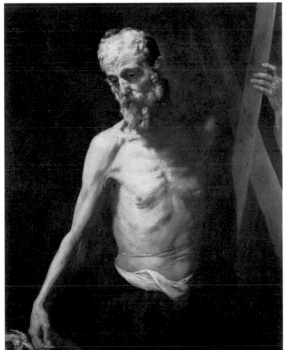

José de Ribera. Saint Andrew the
Apostle *(c.1630). Oil on canvas,*
37 × 48". The Prado, Madrid.
The realism that Caravaggio
introduced toward the end of
the sixteenth century and the
beginning of the seventeenth
endured in the work of many
Baroque painters who, as in
this painting by the Spanish
artist José de Ribera, eschewed
the exaggerations normally
associated with Baroque art.

ON THE THRESHOLD OF THE BAROQUE. CARAVAGGIO

At the close of the sixteenth century, with Mannerism in full swing, Italian art saw the appearance of the figure of Michelangelo Merisi da Caravaggio, one of the painters to have the most influence on the subsequent evolution of painting from the seventeenth century to the end of Romanticism. With his original creative expression, based on formal realism and a special use of light, Caravaggio deviated from the Mannerism mainstream to open up new horizons in painting. Caravaggio was the leading figure of the splendid period of painting in seventeenth-century Europe, which justifies his title as the first Baroque painter.

Influences

All artists come under the influence of others, and Caravaggio must have been no exception. However, if we exclude the documents referring to his apprenticeship in the studio of the painter Simone Peterzano, in Milan, we know absolutely nothing about his early artistic activities.

We may suppose that, during his training as an artist, the painting of his native Lombardy must have influenced the style of the young Caravaggio: the pronounced fidelity to the model, the taste for plasticity of simple objects, the study of the effects of artificial lighting on objects, etc., are characteristics we meet in certain works by Peterzano and the Lombardy painting of the end of the sixteenth century.

Caravaggio's painting represented a radical opposition to the tendencies dominant in the Italian painting of late Mannerism, which makes it difficult to discern any clear influences by contemporary "fashionable" painters.

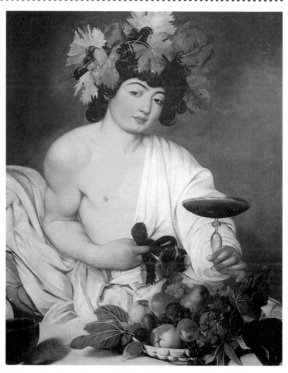

Caravaggio. Young Bacchus (1589). Oil on canvas, 20¹/₂ × 26³/₄". Uffizi Gallery, Florence. In this work by the young Caravaggio, the artist reveals himself to be always faithful to the model. Here, the supposed god is a rather effeminate adolescent, who appears anything but divine. The addition of the magnificently painted vegetables lend to the real image of the adolescent the role of a mythological character.

Caravaggio provoked, as did few other artists, a radical split between his admirers and his critics: "Caravaggio is the Antichrist of painting" proclaimed the Italo-Spanish critic, Vicente Carducho.

Characteristics of Caravaggio's Painting

• The essential characteristic of Caravaggio's painting is his unwavering realism. His characters are always real, neither invented nor idealized. He merely uses them from a position of deep respect for the natural model.

• Caravaggio's religious painting broke with the iconographical models that had traditionally been used for the great biblical or hagiographical themes. This "deviation," this tendency to highlight the human aspects to

the detriment of Mannerism "apotheosis," was very badly considered by the Church.

• In his mature years, Caravaggio was the most brilliant investigator of so-called "luce di bottega" (studio lighting), with which he introduced tenebrism into his works.

Caravaggio's tenebrism is a result of his poetic use of light which enters the scene at an angle, creating sharp, violent contrasts, and combining the impenetrable darkness of the background with the lighted volumes of the bodies.

• Caravaggio's painting gave rise to the "modern" tradition of the still life, a path that Zurbarán, Chardin, and Courbet followed, and which was to lead to the present day under Cézanne.

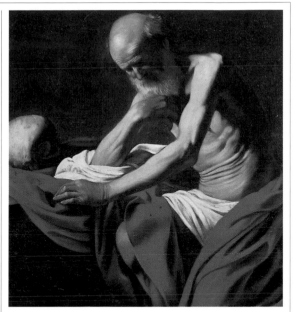

Caravaggio. Saint Jerome (c.1605–1606). Oil on canvas, 31¹/₂ × 46". Museum of the Monastery of Montserrat, Barcelona. A characteristic work of tenebrism, in which the horizontal side lighting contrasts and amplifies the realist details so faithfully captured by the painter.

THE ARTIST'S LIFE

1571. Michelangelo Merisi, named Caravaggio after his native village in Lombardy, is born. It has recently been conjectured that he was actually born in Milan.

1584. Caravaggio starts his apprenticeship in the studio of the painter Simone Peterzano in Milan.

1592. Around this time, Caravaggio appears in Rome. Between this year and 1595, he paints his *Young Bacchus*, his *Penitent Magdalene* and the *Rest on the Flight to Egypt*, works that marked his evolution toward the tenebrism of his later years and the great attraction his sensibility felt for everyday objects.

1595. Cardinal Del Monte, ambassador of the Duke of Tuscany and a great admirer of Caravaggio,

offers him accommodation and board at his residence in the palace of Madama. Thanks to this protection, he is able to paint great works for the Roman churches of Santa María del Popolo, Saint Augustine, Saint Peter's in the Vatican, and Santa María della Scala. The Roman period represents the full development of Caravaggio's plastic expression.

1606. On May 28th of this year, his violent temper leads him to commit a homicide during a quarrel over a ball game. Fleeing from justice, he goes to Naples, where he paints some of his most accomplished religious works.

1607. After another incident, Caravaggio settles in Malta, where he is named Knight of the

Order of the island and where he paints one of his rare portraits: *Adolf of Vignacourt*, Grand Master of the Order of Malta. For obscure reasons, he is expelled from the Order and imprisoned.

1608. He flees to Sicily, where he paints with an intensity that, now back in Naples, marks a certain evolution toward a softening of tonalities and an intensification of dramatism, as shown by the *Martyrdom of Saint Andrew*, one of his last canvases.

1610. On July 16th of this year, as a result of a wound received during one of his frequent fights, he dies in Porto Ecole, on the road to Rome, where he was hoping to receive Pope Paul V's pardon.

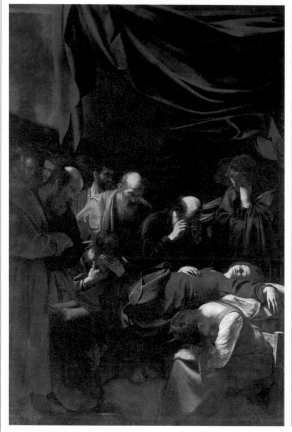

Caravaggio. The Death of the Virgin (1605–1606). Oil on canvas, 95 1/2 × 144". Louvre, Paris. A work of great emotionality, it is one of the peaks of European painting. In this work, Caravaggio re-creates the subject of the death of the Virgin, stripping it of all celestial pomp, to highlight the human aspect of death. The evolution of Caravaggio's expression can be seen in the Magdalene sitting in front of the body of the Virgin: a compact figure, created by large planes of light and shadow which, seen from above, is a clear expression of human grief.

The Influence of Caravaggio

Caravaggio is one of the artists who exercised the most influence on European painting, and not only during the Baroque period. The aesthetic use of light he introduced in the early years of the seventeenth century (tenebrist painting) and, in particular, the realism he applied to biblical characters, influenced the work of prestigious painters to come, especially in the field of religion, in which his most representative ideas were taken up. The Carracci brothers, Guido Reni, Domenichino, Il Guercino, Caracciolo, Preti, Vaccaro, and other great figures of the seventeenth-century Italian painters all made use of Caravaggio's techniques at some time in their artistic careers, of Caravaggio's ideas, and not only in Italy.

Noted works from Caravaggio's extensive production include:

Young Bacchus (1593–1594). Uffizi Gallery, Florence.

The Penitent Magdalene (1595). Doria-Pamphili Gallery, Rome.

The Martyrdom of Saint Matthew and *The Calling of Saint Matthew* (1598–1601), Contarelli Chapel, church of San Lugi dei Francesi, Rome.

Crucifixion of Saint Peter and *The Conversion of Saint Paul* (c. 1605), Cerasi Chapel, church of Santa María del Popolo, Rome.

Saint Anne, the Virgin and the Child (c. 1606), St. Peter's, Rome, currently in the Borghese Gallery, Rome.

The Seven Works of Mercy (1606–1607), painted in Naples for the Chapel of Monte della Misericordia.

The Flagellation of Christ (1606–1607), church of San Domenico Maggiore, Naples.

The Beheading of St. John the Baptist (1607–1608), painted in Malta. Valetta Cathedral, Malta.

The Burial of Saint Lucy, The Resurrection of Lazarus, The Adoration of the Shepherds, and *The Adoration with St. Francis and St. Lawrence,* painted in Sicily between 1608 and 1609.

The Martyrdom of Saint Ursula (1609–1610), painted in Naples during the last months of his life. Banca Comerciale Italiana, Naples.

Introduction **13**
On the Threshold of the Baroque. Caravaggio
Beginning of the Academies. The Carracci Bros.

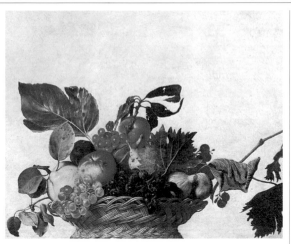

Caravaggio. The Basket of Fruit *(1596). Oil on canvas, 18¹/₄ × 12".*
Pinacoteca Ambrosiana, Milan. This painting is considered the first
"modern" still life. With the intertwined wicker, the treatment of the
fruit, some of it healthy, some of it rotten, the drops of moisture on
the leaves, some healthy, others withered; the detailed study of light,
shadow and half-light, this painting is a true exercise in realist virtuosity.
Caravaggio himself said that he "needed the same skill to paint a flower,
as to paint a human figure."

paintings was a common element in Caravaggio's work. They are true still lifes, elaborated with the same care as the protagonist, with whom the still life often maintains a close relationship. This represents another of Caravaggio's contributions, and shows his interest in humanizing what historically and ideally had been represented with grandiloquent idealization of the superhuman.

After Caravaggio, great artists such as Velázquez revealed their skill as still-life painters, while others, such as the French painter Chardin for example, became true specialists in the genre.

There is a before and after Caravaggio in European painting; he was an artist who was soon to become a reference point for his contemporaries as well as future painters.

In Spain, for example, Baroque painting produced masterpieces influenced by the tenebrist realism of Caravaggio. Zurbarán and Ribera, two of the finest painters of the seventeenth century, are excellent examples of his influence.

The aesthetic revolution that Caravaggio's ideas caused at the time, apart from a special, poetic use of light, was centered on replacing idealized figures (in both profane and mythological or religious themes) with realist ones painted from nature and "acting out" the role assigned to them. This realism is visible also in detail: Caravaggio delights in representing secondary elements that, in one form or another, come to complement the main theme. This reappraisal of simple, everyday subjects gave rise to a specific genre still lifes which, during the seventeenth and eighteenth centuries was to reach the peak of achievement. As we shall see, the still-life genre developed in Spain, France, Flanders, and Holland, fundamentally. The

presence of ceramic objects or other materials such as wicker baskets, for example, arranged in a corner of one of his large

Caravaggio. The Last Supper at Emaus *(1606). Oil on canvas,*
68¹/₄ × 55". Pinacoteca de Brera, Milan. Another example of
Caravaggio's realist and poetical ideal, as he fills his biblical scenes
with contemporary men and women. A horizontal side light reveals,
against the dark background, people who serve no other purpose than to
represent themselves, regardless of the evangelical scene being depicted.

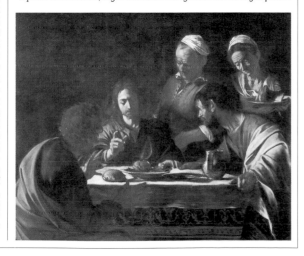

BEGINNING OF THE ACADEMIES.
THE CARRACCI BROTHERS

Throughout the entire Middle Ages and well into the Renaissance, design was considered a craft, a *mechanical art*. Michelangelo himself insisted on the idea that "you paint with your head, not your hands," in an attempt to make contemporary society realize that painting should be ranked on the same intellectual level as music and poetry, considered the *liberal arts*. In this struggle for recognition of the fine arts, which continued well into the eighteenth century, the Academies appeared as a higher pedagogical alternative for training liberal professionals, removed from the guilds and their rules.

The Carracci Brothers

In 1585, in the city of Bologna, the brothers Agostino and Annibale Carracci, together with their cousin Ludovico Carracci, founded the *Accademia dei Desiderosi* (desirous of fame and learning) which was soon named *Accademia degli Incamminati* (Progressives), and which is considered the first "modern" fine arts academy.

The life of the *Accademia degli Incamminati*, on which the artistic and cultural activity of Bologna was centered, was a short one (until 1619). But the work of the Carraccis was decisive in "directing" a younger generation toward the aesthetic ideals of the Baroque.

Agostino Carracci

Born in Bologna in 1557, he is best described as the true founder of the *Accademia degli Incamminati*.

A painter of little personality, he had a true vocation for teaching and was a noted engraver, whose work was closely associated with the teaching of drawing. He died in Parma in 1602.

Noted works by Agostino Carracci include:

Amor Leteu, Kunsthistorische Museum, Vienna.

The Last Communion of Saint Jerome, National Art Gallery, Bologna.

Ludovico Carracci

He was born in Bologna in 1555 and died in the same city in 1619. Ludovico was a cousin of Agostino and Annibale, with whom he cofounded the

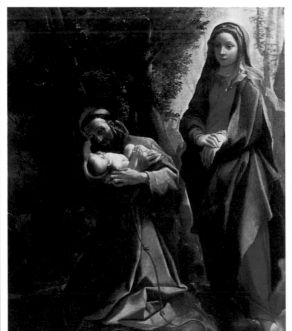

*Ludovico Carracci.
The Vision of Saint Francis (1585).
Oil on canvas. 34³/₄ × 40".
Rijksmuseum, Amsterdam. The compositions by Ludovico Carracci are generally simple ones. In this canvas, for example, the artist proposes a relationship between celestial figures (the Virgin and the Infant Jesus) and a human character, Saint Francis. Ludovico symbolizes the relationship between the divine and the earthly by means of the light (where the celestial theme is situated) and the darkness, from which, in the tenebrist fashion, the human character emerges. This is done without pomp or show, but with the same simplicity and naturalness that he painted domestic, everyday scenes.*

On the Threshold of the Baroque. Cavavaggio
Beginning of the Academies. The Carracci Bros.
Toward the Height of the Baroque (I)

15

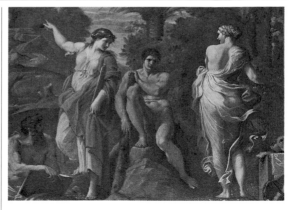

Annibale Carracci. The Choice of Hercules (1595–1597). Oil on canvas, 92 1/2 × 65". Capodimonte Museum, Naples. This painting forms part of the decoration of the room known as "Il Camerino" in the Palazzo Farnese, in Rome. Hercules, debating between virtue and vice, is a beautiful example of Annibale's profound assimilation of the Renaissance sensibility, basically Raphael-like Classicism and the further proof of how the pictorial empiricism of Annibale Carracci enabled him to switch comfortably between the different tendencies of his most admired artists.

Accademia and also shared responsibility for it. His paintings are characterized by the simplicity of the composition, conceived as architectural scenes, with clean, evident volumes, within a perspective in line with Renaissance interiors. Another facet of his activities between 1585 and 1594 were important murals in Bologna, which he painted along with Agostino and Annibale.

Noted Works by Ludovico Carracci Include:

The Annunciation, Pinacoteca, Bologna

The Vision of Saint Francis, Rijksmuseum, Amsterdam.

Co-decorator of the Fava, Magnani, and Sampietri palaces in Bologna.

Annibale Carracci

Influences

Annibale was trained under the influence of the Venetian painters who advocated direct observation from nature.

Raphael (whom he studied closely) and the work of the great artists of the Renaissance were another of the major influences assimilated by Annibale Carracci.

THE ARTIST'S LIFE

1560. Annibale Carracci, the younger of the Carracci brothers, is born in Bologna.

1584. Together with Agostino and Ludovico, he works on the decoration of the Palazzo Fava in Bologna.

1588–1591. He participates in the mural decoration of the Palazzo Magnani in Bologna.

1593–1594. He decorates the Palazzo Sampietri in Bologna, together with Ludovico and Agostino.

1582–1594. This is the artist's mature period when, in addition to works such as the frieze decorations which he shared with the other artists, he develops an interesting activity as an easel painter, painting works on different themes (in the religious, mythological, popular, genres) in which he

shows his supple style, a result of his eclectic approach to form and color, with constant "references" to Raphael, Titian, and the Veronese.

1595. He is called to Rome, with his brother Agostino, to decorate the palace of Cardinal Odoardo Farnese, the largest in Rome. Although he finally received the help of such significant disciples as Domenichino and Lanfranco, the larger part of the work fell to Annibale, especially the fresco in the dome of the main hall: *The Triumph of Bacchus.*

1603. As a result of the strain suffered during the decoration of the Palazzo Farnese, the first symptoms of the disease that was to lead him to an early death appeared.

1604. He paints one of his finest oil works: *Pietà* or *The Weeping of the Three Marys,* an impeccable painting.

1604–1605. He paints the frescos, with landscapes and figures, for six lunettes in the Palazzo Aldobrandini, in Rome. These windows (some painted solely by Annibale Carracci), mark the start of Baroque landscapes of a Classicist tendency, in which the observations of nature are arranged in an idealized fashion, in accordance with a clear process of selection and organization. Annibale Carracci foments Baroque Italian painting, which is to influence the art of the great Spanish, Flemish, Dutch, and French painters.

1609. He dies in Rome.

Characteristics of Annibale Carracci's Painting
• His painting is eclectic; this should be understood as an attempt to bring together in a single aesthetic ideal, the formal purity of Raphael, the elegance of Correggio, and the color of Titian and Veronese.
• The result was a highly formal, yet extraordinarily ductile style.

Annibale is considered the best painter in the Carracci family and one of those who, in the transition from Mannerism to the Baroque, most influenced the painting of the seventeenth and eighteenth centuries.

Noted among Annibale Carracci's easel works (altar paintings, mythological and popular works) painted during what we have called his mature period (1582–1594), approximately.

The Carnage (1582–1583), in Christ Church College, Oxford.

Il Mangiofagioli (The Bean Eater), Borghese Gallery, Rome.

Pietà, Parma Gallery.

The Madonna of Saint Luke (Virgin with Child and Saint Luke), Louvre, Paris.

The Madonna of Saint Matthew, Dresden Museum.

The Assumption of the Virgin (several versions), in the museums of Bologna, Dresden, and The Prado.

Venus, Adonis, and Cupid, The Prado, Madrid.

Venus with Satyr and Cupid, Uffizi Gallery, Florence.

The Triumph of Bacchus (1597–1600). Large central fresco of the dome of the great gallery of Palazzo Farnese, Rome.

The Pieta or *The Weeping of the Three Marys* (1605), National Gallery, London.

The Flight into Egypt and *The Burial of Christ* (1604–1605). Lunettes of the Palazzo Aldobrandini, entirely painted by Annibale Carracci. Doria-Pamphili Gallery, Rome

• As a fresco painter, Annibale Carracci won his fame with the decoration of the Palazzo Farnese in Rome. This grandiose work, in which his brother Agostino painted the secondary items, established iconographical models and a volumetric style, with excellently drawn figures in pale colors, and was to influence all subsequent mural work.
• As a painter of religious themes, Annibale Carracci's style incorporates features used by Caravaggio, above all his lighting, although his approach to tenebrism was not completed. We could call it "light" tenebrism, with more "detailed" backgrounds and softer contrasts.
• Annibale's interests led him to experiment in other directions in the field of graphic expression and subject matter. Evidence of this are paintings such as *The Carnage* at Christ Church College, Oxford and *Il Mangiofagioli* (The

Annibale Carracci. *The Triumph of Bacchus, fragment (1597–1600). Central fresco of the dome of the great gallery of the Palazzo Farnese (25⁷/₈" × 78¹/₂"). Allegory of divine love that leads Ariadna to a state of eternal contemplation. The figure of Venus and the satyr symbolize human love (Venus) and bestial or voluptuous love (the satyr). A masterpiece that is basic for later mural painting.*

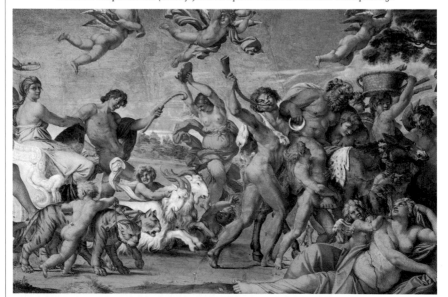

On the Threshold of the Baroque. Caravaggio
Beginning of the Academies. The Carracci Bros.
Toward the Height of the Baroque (I)

17

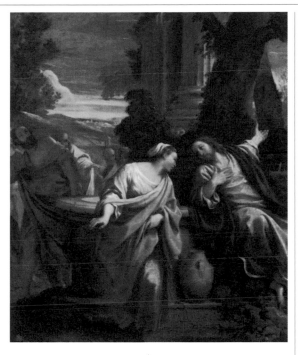

Annibale Carracci. Jesus and the Samaritan. *Oil on canvas, 24³/₄ × 28⁵/₈". Budapest Art Museum. This easel painting, painted at the same time as the decoration of the Palazzo Farnese is a beautiful example of Annibale Carracci's religious painting, in which we see his faithfulness to the eclectic aesthetic he taught in his academy. Together with a Raphael-inspired search for formal perfection and distribution of space, a use of color and atmosphere that are reminiscent of Titian and Veronese, the dramatic realism in the gestures and expression reveal his Baroque sensibility. The attempt to combine the formal Classicism of Raphael with the colors of Titian and Veronese is not mere mimetic eclecticism on the part of Annibale Carracci, but a work of great quality and coherence.*

Bean Eater), at the Borghese Gallery, Rome. Annibale and his brother Agostino are considered among the first caricaturists. A landscape artist as well,

Annibale's painted lunettes for the Palazzo Aldobrandini in Rome, marked the starting point for Classicist landscape painting. There he organized and arranged

in a rational order the elements he had taken from nature and transformed them into an idealized landscape. This movement, from Annibale Carracci onward, was to dominate Baroque landscape painting and even influence Romantic landscapes.

Annibale Carracci. Fragment of the Dome of the Great Gallery of Farnese Palace, Rome (1597–1600). In this dome (which the photograph cannot capture in its entirety) and also on the walls of the great gallery, the painter developed a complex set of icons, almost certainly thanks to the librarian of the Palazzo Farnese, Fulvio Orsini. This set of icons is a visual expression of the platonic concept of three types of love: contemplative, active, and voluptuous. Thus, what at first sight appears to be a set of erotic scenes somewhat unsuitable for the rooms belonging to a prince of the church, when they are interpreted in humanistic terms, constitute an allegorical apotheosis of the highest feeling humankind can experience. This distribution of space into closed scenes is similar, to a certain extent, to Michelangelo's work in the Sistine Chapel.

TOWARD THE HEIGHT OF THE BAROQUE (I)

The evolution of the Italian painting of the 17th century toward the height of the Baroque period during the 18th century is heavily influenced by the work of the reputed masters who had trained at the Accademia degli Incamminati. Within the eclecticism so characteristic of the Academy, painting shifted from the academic idealism of Guido Reni and the Raphael style of Domenichino, toward Venetian colorism, represented by Il Guercino and the frescos by Lanfranco, which display the dynamism of the masses, a characteristic feature of 18th-century Baroque.

Guido Reni

Influences

Guido Reni is the most famous among the disciples of the Carracci brothers, on whose eclectic ideal he based his work. Caravaggio was at the height of his controversial fame, and Reni, in certain contemporary works, shows that he has assimilated the realism and tenebrism of the painter from Lombardy.

Guido Reni. David and Abigail. Oil on canvas, Museum of Fine Arts, Budapest. Within a clearly tenebrist style, Reni maintains his idealistic approach in one of the less dramatic biblical scenes. The idealization of the characters is apparent in the female figures, while David is treated in a more realist fashion.

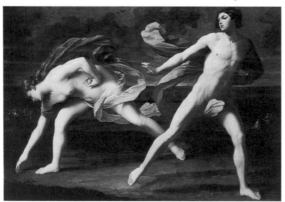

Guido Reni. Atalanta and Hippomenes (1612). Oil on canvas, 78³/₄ × 76³/₄". The Prado, Madrid. A Classicist idealist interpretation of the legend: the woman picks up the golden apples cast down by Hippomenes, a trick that allows him to win the race and the woman in marriage.

Characteristics of His Painting

• Reni's realism is merely a passing reflection of Caravaggio.

• What really distinguishes Reni's painting is his eclecticism: the variety of pictorial concepts that are brought together. The Italian literature of the day, depending on the circumstances, defined Reni's painting as elegant, tender, worthy, delicate, easy, and beautiful.

• The idealism that separated Reni from realism gave rise to a certain mannerism.

• In his later works, Reni's brushwork is more flowing, and his painting more focused on the essential.

THE ARTIST'S LIFE

1575. He is born in Calvenzano, near Bologna. He studies music (his father is a musician), although he soon starts to study painting in the studio of a painter called Denys Calvaert.

1595. He enters the academy of the Carracci brothers.

1602. He travels to Rome, where he comes under the influence of Caravaggio.

1613. He finally settles in Rome and works for Pope Paul V and Cardinal Scipione Borghese.

1622. He travels to Naples to carry out a commissioned work. He suffers an attack and returns to Bologna.

1642. He dies in Bologna. Although Guido Reni was one of the most famed and rewarded artists of his time, his passion for gambling meant he was completely ruined when he died.

Beginning of the Academies. The Carracci Bros.
Toward the Height of the Baroque (I)
Toward the Height of the Baroque (II)
19

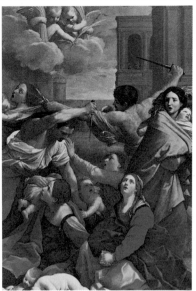

Guido Reni. The Slaughter of the Innocents (1612). Oil on canvas, 68 1/4 × 104 1/2". National Art Gallery, Bologna. Highly rigid composition with which Reni approaches the crude realism of Caravaggio.

Domenico Zampieri, Domenichino

Brief Summary of His Life and Works

Another great painter to emerge from the Accademia degli Incamminati was Domenico Zampieri, called Domenichino.

Born in 1581 and greatly influenced by the Carracci brothers, he relied heavily on drawing and the study of Raphael's work regarding composition and gesture.

In 1608 he had his first major success as a painter (in competition with Guido Reni), with his fresco for the church of Saint Gregory the Great, in Rome, *The Martyrdom of Saint Andrew.*

Noted Works by Guido Reni Include:

The Crucifixion of Saint Peter (1603), a work showing the influences of Caravaggio. Vatican Art Gallery.

Saint Andrew Taken to Martyrdom, church of San Gregorio, Rome.

The Crucifixion, National Art Gallery, Bologna.

The Dawn (1613–1614), fresco in the Rospigliosi Palace, Rome.

Girl with Crown, Capitolina Art Gallery, Rome.

The Suicide of Lucrecia, Capitolina Art Gallery, Rome. This painting and the previous one are representative of Reni's later style.

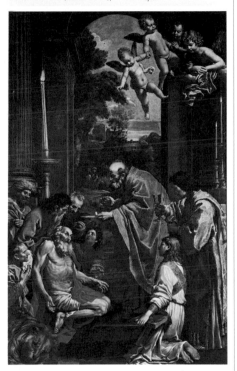

Domenichino. The Communion of Saint Jerome. Oil on canvas, 99 7/8 × 163 1/2". Vatican Art Gallery. An example of Zampieri's chiaroscuro, different to the greater linearity of his fresco compositions.

He continued with the frescos for the abbey of Grottaferrata and the *Life of Saint Cecilia,* for the church of S. Luigi dei Francesi, also in Rome. Noted works by him include: *Diana's Hunt,* in the Borghese Gallery, Rome; *The Martyrdom of Saint Andrew,* in S. Andrea della Valle, Rome; *The Frescos of the Dome of Saint Charles,* in Rome; *Susana,* in the Museum of Munich; *David,* in Versailles.

Domenichino died in Naples in 1641.

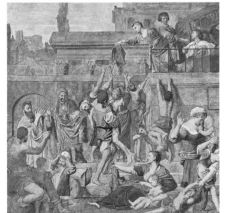

Domenichino. Saint Cecilia Sharing Her Clothes Among the Poor. Fresco, 132 5/8 × 132 5/8". Church of S. Luigi dei Francesi, Rome. In his frescos, Zampieri reveals his liking for the work of Raphael.

TOWARD THE HEIGHT OF THE BAROQUE (II)

The works of Caravaggio, the colorist achievements of the later Mannerism and the teachings of the Carracci brothers influenced the palette of their most famed disciples: the idealism of Reni, the Raphael-like style of Il Domenichino, the Venetian fondness for color, as used by Guercino and the daring representation of human crowds in motion, as experimented with by Lanfranco.

Il Guercino

Influences

Giovanni Francesco Barbieri (1591–1666), known as Il Guercino on account of his squinting, was heavily influenced, first by Caravaggio and later by Titian, Tintoretto, and Veronese. During his studies at the Academia degli Incamminati, he was attracted to the colorism of Ludovico Carracci.

Characteristics of His Painting

During his early stages, Il Guercino adopted the tenebrist style of Caravaggio. Yet toward 1618, he discovered sixteenth-century Venetian painting, and his work took on a form of colorism strongly related to later Mannerism. This is attractively naturalist painting, with sumptuous use of color, changing light effects, and displays of perspective that characterize his short period as a Roman painter.

The critic, Mateo Marangoni (1876–1958) said, in reference to this Roman period, that at this time one can find "the true Guercino."

On his return to Bologna, his style was influenced by Guido Reni and Domenichino, and it returned to their initial teaching on the treatment of color and light.

Il Guercino. The Virgin of the Swallow. Uffizi Gallery, Florence. An example of the sumptuous use of color and compositional elegance so characteristic of this painter's work.

THE ARTIST'S LIFE

1591. He is born in Cento. Son of peasants, he never ceased to consider himself a country person, despite being universally famous.

1607. He enters Gennari the Elder's studio as an apprentice.

1610. He attends the Carracci Academy at about this time.

1621–1623. He works in Rome, summoned by Cardinal Alejandro Ludovisi, the future Pope Gregory XV.

1624. He settles again in Bologna and in his place of birth, Cento. A simple man, Il Guercino is reluctant to abandon his surroundings and systematically rejects tempting offers from many European courts.

1652. It is known that about this year he receives 150 gold escudos (a fortune at the time) from Cardinal Machia-velli for his *Saint Sebastian*, one of his last works.

1666. He dies, December 22nd, in Cento, one of the best-loved painters of his time.

Toward the Height of the Baroque (I) **21**
Toward the Height of the Baroque (II)
The Roman School and the Neapolitan School

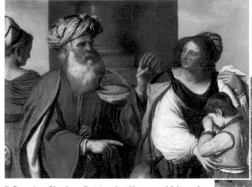

Il Guercino. Abraham Driving Out Hagar and Ishmael *(c.1621). Oil on canvas. Pinocoteca di Brera, Milan. The monumental nature of the figures, painted with a steady and accurate hand, the colorism inherited from Ludovico Carracci, as well as the clear influence of Tintoretto and Veronese are the distinguishing features of Il Guercino's works during his Roman period.*

Il Guercino. The Dawn *(1621). Frescos, a fragment of the ceiling of the Casino Ludovisi, Rome. With this fresco decoration, Il Guercino introduced inverse perspective. With the supposedly horizontal plane of the painting, the vertical edges vanish upward and converge at a single zenithal point.*

Giovanni Lanfranco

Brief Summary of His Life and Works

He was born in 1582 and died in 1647. He studied at the Adcademia degli Incamminati. He worked in Rome as an assistant to Annibale Carracci, whose pictorial idealism he moved away from, turning instead to the naturalism of Caravaggio, to daring mural paintings of multitudes in motion, with pronounced foreshortening. Lanfranco was a highly significant (though not one of the most famous) painters during the evolution of the Baroque style. His frescos are, indeed, the forerunners of the large Roman murals whose Baroque style culminated in the 18th century. Fine examples of this are his *frescos for the dome of San Andre della Valle* (1621–1627), in Rome; *The Glory of the Blessed,* in the dome of the chapel in the church of San Gennaro, Naples, or the *frescos of San Carlo ai Catinari* (c.1647), in Rome.

Noted Works by Il Guercino Include:

The Crucifixion, church of Our Lady of the Rosary, Cento.

The Prodigal Son, History of Art Museum, Vienna.

The Burial of Santa Petonilla, Capitoline Museum, Rome.

Et in Arcadia Ego, in the National Gallery of Ancient Art, in Rome, as well as several works conceived under the impact of the works by Veronese and Titian: *Caesar and Cleopatra,* and *Herminia and Tancredo,* among others.

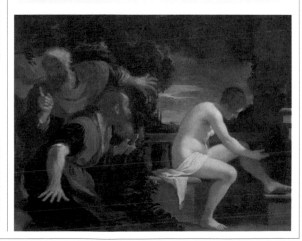

Il Guercino. Susan and the Elders. *Oil on canvas 80³/₄ × 68¹/₄". The Prado, Madrid. An easel painting of extraordinary plasticity, in which Il Guercino displays his fondness for monumentally structured figures, with a certain pomposity of forms, showing the influence of Raphael and perhaps that of Reni and Domenichino.*

THE ROMAN SCHOOL AND THE NEAPOLITAN SCHOOL

Baroque Italian painting had as its focal points cities with, for one reason or another, an unusual creative force or, as was the case of Rome, an enormous capacity for acquiring the services of great artists. We already saw the case of Bologna which, with the Carracci brothers and their disciples, created an authentic pictorial school. Other schools had their origins in Naples and, during the eighteenth century, in Venice. Rome was a different case. Although historically we refer to the Roman school, the wealth of the artists that city acquired during the seventeenth century cannot be considered a product of the city itself, but the result of the popes' and other church dignitaries' patronage of contemporary artists, thanks to which they went to the Vatican to work.

The Painters of the Roman School

The city of Rome was the center of political and social life during the sixteenth, seventeenth, and eighteenth centuries. Under the patronage of the popes and the high dignitaries of the Catholic Church, it was also the center of European art and attracted the great Baroque painters, each with his own aesthetic concepts that, in brief, moved between the naturalism of Caravaggio, the eclecticism of the Bologna school, the enduring influence of Renaissance painting, and the strong colorist influences of late Mannerism.

Rome, undoubtedly, was the capital of art, though not an exclusive art, a style of painting with Roman roots. Those who endowed the city temples and

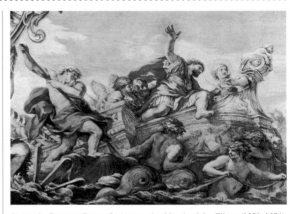

Pietro da Cortona. Eneas Arrives at the Mouth of the Tiber *(1651–1654). Fresco painting in the Doria-Pamphili Palace, Rome. The foreshortened drawing lends continuity to the space, which seems to extend upward, in a style reminiscent of Annibale Carracci.*

palaces with Baroque splendor were not Roman and no one style came to dominate the others.

Giovanni Battista Gaulli. Prudence *(1674–1679). Fresco at the church of Gesù, Rome. The elegance, the perfect modeling of these allegorical figures is pure Raphael, while the movement and situation, opening upward, belong to the tastes of other Baroque Roman painters of the seventeenth century.*

Yet, despite the lack of a common concept, as befits a school, the works painted in Rome during the second half of the seventeenth century revealed a common taste for the exaltation of the Baroque: illusionist, unreal compositions, pronounced foreshortening, inverse perspective, and a special fondness for fresco murals.

The Great Fresco Painters

Pietro da Cortona (1596–1669), whose real name was Pietro Berrettini, was born in Cortona, city of old Tuscany (province of Arezzo). In addition to being a painter, he was also a fine architect, who alternated his work as a fresco painter with the

Toward the Height of the Baroque (II)
The Roman School and the Neapolitan School
Luca Giordano

23

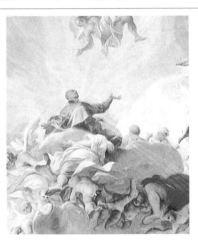

Andrea Pozzo. The Glory of Saint Ignatius. *Fragment of this Allegory of the Missionary Work of the Jesuits (1691–1694). Fresco in the church of Saint Ignatius, Rome. This apotheosis of ascendent movement, pale, gentle, and transparent colors, with highly pronounced foreshortening, suggests a space in which the bodies, weightless, share the ethereal warmth of the light.*

construction of funeral monuments and architectural projects. He was undoubtedly the great mural painter of Rome during the first half of the seventeenth century.

His fine murals include those in the gallery at the Mattei Palace, in Villa Mutti de Frascati, near Rome, those at the church of Santa Bibiana, Doria-Pamphili Palace, Rome and the Pitti Palace in Florence.

Giovanni Battista Gaulli Il Baciccia (1639–1709), was the painter of one of the most representative works of large scale mural painting at the ill-named Roman School. We refer to *The Adoration of the Name of Jesus*, on the ceiling of the Gesù church in Rome. With the elegance of his compositional style, the Classicist tendency of his nudes and the sober use of color, Gaulli reveals himself to be a follower of Raphael, "influenced" by Baroque exaltation.

Andrea Pozzo 1642–1709). This Jesuit priest, born in Trento, was an established architect as well as a painter. As an artist, he became famous for his extraordinary mastery of the decoration of domes, which led him to paint in Rome, in Arezzo, Verona, Modena, Turin, and Vienna, where he was summoned by the emperor Leopold.

He is the main exponent of Baroque dramatism placed at the service of the church, with paintings that stretch upward in an architectural style in search of infinite space, as we can see in his most representative work: *The Glory of Saint Ignatius* (Allegory of the Missionary

Work of the Jesuits), in the church of Saint Ignatius, Rome.

Salvator Rosa (1615–1673). The interest this painter (born in Arenella, near Naples) arouses in the history of art, does not lie in his compositions with battles (his favorite theme) nor in his figures, but in his landscapes, in which he was a leading artist. These landscapes, with their earthy, gray colors, follow a dynamic composition, arranged along curved compositional lines. We know that his assistants prepared the paints for him to apply the final touches, the notes of light that lend personality to a style of landscape that influenced the evolution of this genre in Europe until well into the nineteenth century.

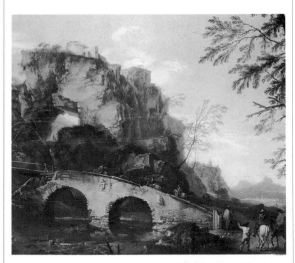

Salvator Rosa. The Broken Bridge *(1641). Oil on canvas, $36^{7}/_{8} \times 39^{3}/_{4}$". Uffizi Gallery, Florence. In general, the foreground in Rosa's landscapes, with their wide spaces full of sharp shadows, contrast with a gently lit background.*

Salvator Rosa. Self Portrait *(detail of the head). Uffizi Gallery, Florence. Although his most original works were his landscapes, Rosa was a specialist in painting battles and an excellent portrait painter who could capture states of mind.*

The Neapolitan School

The school of painting headed by Caracciolo that developed in Naples following the early years of the seventeenth century imposed aesthetic criteria followed by painters as Stanzione, Cavallino, Preti, Vaccaro, Falcone, and other lesser painters. The Neapolitan School, as it was called, was centered on the aesthetic principles of Caravaggio, blending classical elements with the eclecticism of the Carracci brothers.

Giovanni Battista Caracciolo (c.1570–1637), called Il Battistello, is considered the true founder of the seventeenth-century Neapolitan School. His Caravaggio-like aesthetic premises appeared in his works painted during the period 1607–1615, among which are *The Immaculate Conception* and *The Liberation of Saint Peter*. During his stay in Rome, around 1614, his tenebrist realism took on features of classical elegance (Raphaelesque), through studies of the works of the Carracci brothers. This influence can be noted, above all, in his frescos, in which, Caravaggio-style, he evolves toward a more luminous painting technique.

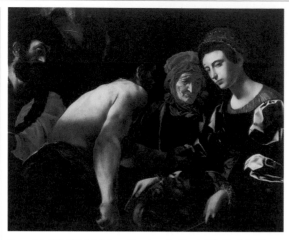

Caracciolo (Il Battistello). Salome Receives the Head of the Baptist. Oil on canvas, 60⁷/₈ × 51¹/₂". Uffizi Gallery, Florence. This is a magnificent example of Caravaggio's aesthetic concerns put into practice by Caracciolo.

Mattia Preti (1613–1699) was the first of the great masters of seventeenth-century Baroque Italian painting and also, without a doubt, the major representative of the contemporary Neapolitan School. Born in the town of Taverna, in Calabria, he went to Rome in 1630 and traveled around the regions of Emilia and Veneto. From 1656 to 1661 he lived in Naples, where he was known as the Cavaliere Calabrese. There he developed his definitive style, which shows clear influences of the tenebrist-naturalist painting of the Lombardy painters such as Il Guercino and Lanfranco, in addition to Titian and Tintoretto, especially in his later works.

He spent the latter years of his life in Malta, where he arrived in 1653 and where he painted various works for the Order of Malta (church of San Juan de La Valletta) and several portraits.

Mattia Preti. Saint John Rebuking Herod (1662–1666). Oil on canvas, 78³/₄ × 54¹/₂". Museum of Fine Arts, Seville. Composition arranged along a traversal axis, clearly influenced by tenebrist naturalism.

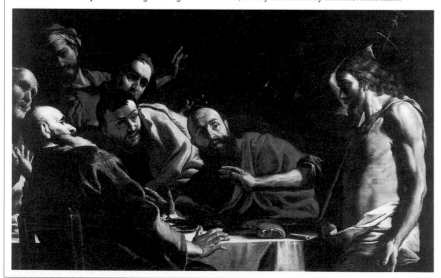

Toward the Height of the Baroque (II)
The Roman School and the Neapolitan School
Luca Giordano

25

Massimo Stanzione. The Beheading of Saint John the Baptist. Oil on canvas, 100³/₄ × 71³/₄". The Prado, Madrid.

Massimo Stanzione (1586–c.1658). Born in Orta de Antella, near Naples, he was known as the Guido Reni of Naples, a title which suffices to define the stylistic leanings of this painter, a rival of the Spaniard Ribera in painting naturalist works in the style of Caravaggio. This naturalism and the classicism of the School of Bologna, signify that Stanzione's painting, as far as style was concerned, had one foot in Rome and another in Naples.

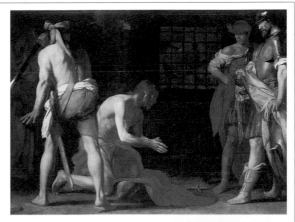

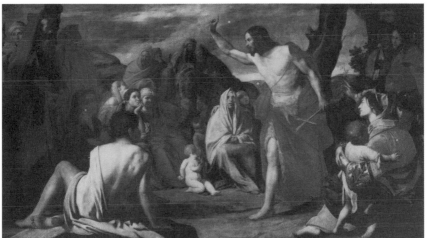

*Massimo Stanzione.
Saint John the Baptist Preaching.
Oil on canvas, 130³/₄ × 73".
The Prado, Madrid. This painting by Stanzione is in line with the previous one (The Beheading), revealing also the clear influence of Guido Reni. More apparent here, perhaps, is the attempt to capture Caravaggio's realism.*

Andrea Vaccaro. Descent from the Cross. (1635–1640). Oil on canvas, 59¹/₄ × 78". Monte de la Misericordia, Naples. This is, perhaps, his most representative work. It is a magnificent composition, distributed along two transversal axes that guide the movement of all the elements of the painting. It shows the influence of Domenichino, Stanzione, and Reni, in an atmosphere with a certain religious romanticism created by the light.

Andrea Vaccaro (c.1598–1670). Born in Naples, he was one of the representative of the Neapolitan School. His painting shows the influence of Domenichino (who went to Naples to paint the dome of the S. Gennaro chapel in the cathedral), of Stanzione, and Guido Reni.

LUCA GIORDANO

The splendor of Neapolitan painting during the seventeenth century and the fact
that the city had acquired a true tradition of mural painting and a first-class artistic
atmosphere, helped these painters of the turn of the century to take over from
their predecessors (Giordano, Lanfranco, Preti, etc.). Luca Giordano was
the Neapolitan artist who led the mural painting of the seventeenth
century to the doors of the eighteenth.

Luca Giordano. Solomon's
Dream *(c.1694). Oil on
canvas, 95¹/₂ × 140³/₄". The
Prado, Madrid. His mastery of
drawing and composition,
and the brilliant use of color
employed in his sumptuous
works are apparent in this
fine oil painting (a mural
painting on canvas), with
its composition arranged
along curved lines that tend
to come full circle, a feature
we can see in many of his
great murals.*

Luca Giordano's Painting

Influences and Characteristics
A disciple of Ribera and Pietro
da Cortona, Luca Giordano
(known in Spain as Lucas Jordán),
was very familiar with the
Flemish masters, with Veronese
and Titian, from whom he
acquired certain compositional
and chromatic characteristics.
Giordano's art, however, can in
many ways be described as
mimetic. He never imitated.
Rather, his style was an
adaptation of teachings and
influences which he made his
own, and which are charac-
terized by:
• Precise, yet flowing brush-
work, lending his paintings great
vitality.

• Spectacular, elaborate and
dramatic compositions.
• A drawing style that is
similar to Ribera's and a use of
color reminiscent of his masters,
such as the forceful, attractive
frescos by Veronese.

• The expression and move-
ment of his figures which,
despite their conventionality,
appear to be absolutely spon-
taneous. This apparent spontan-
eity is the result of his mastery
of drawing.

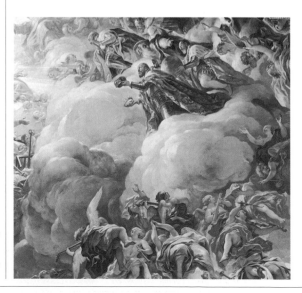

Luca Giordano.
Detail of the Paintings in the
Monastery of the Escorial.
*Frescos, Escorial, Madrid. A fine
example of the huge vitality of
Giordano's painting. All the
postures tend to lead the eye
along a curved line that runs
around the entire composition.*

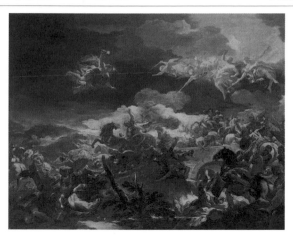

The enormous speed at which Giordano could paint earned him the nickname "Luca fa presto."

Luca Giordano. The Defeat of Sisara. Oil on canvas, 50¹/₂ × 46³/₄". The works Giordano painted in a smaller format maintain the spectacular nature of his composition and the use of color of his large mural paintings. It is, perhaps, in these less monumental oil works where the precise, vigorous, and expressive brushwork of "Luca fa presto" is best observed.

THE ARTIST'S LIFE AND WORKS

1632. Luca Giordano is born in Naples. An untiring traveler, his life was spent in Naples, Rome, Florence, Venice, Madrid, and again Naples.

1677. He paints the frescos for the abbey of Monte-casino.

1682–1683. He paints the frescos in the main salon of the Medici-Riccardi palace in Florence.

1692. He arrives in Spain as a painter in the court of Charles II, where he was known by the Spanish version of his name: Lucas Jordán. He is appointed chamber painter, a post he holds for the ten years he lives in Madrid, until 1705. He paints large fresco works: on the main staircase of the Monastery of El Escorial, where he also painted fine examples of oil works on canvas (*The Flight to Egypt*, for example), in the Casón del Buen Retiro park (related to the order of the Golden Fleece) and the sacristy of the cathedral in Toledo.

1705. He dies on his return to Naples from Spain. He paints his last work in his native village, the decoration for the chapel in the San Martino charterhouse.

Brief Summary of Francesco Solimena

On Giordano's death, Francesco Solimena (1657–1747) was to become the main representative of the Neapolitan School during the first half of the eighteenth century.

His works reveal not only the influence of Cortona and Giordano, but also a profound study of the art of Lanfranco and Preti.

Without forgetting his great talent as a painter, history remembers him also as the master of another great mural painter of the eighteenth century: Corrado Giaquinto.

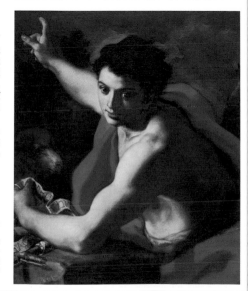

Francesco Solimena. Saint John the Baptist. Oil on canvas, 27¹/₄ × 32¹/₄". The Prado, Madrid. An impeccable work, this young figure of St. John the Baptist reveals the mastery of the painter, also true of numerous contemporary painters who left evidence of their complete command of the art.

PAINTING AFTER GIORDANO

The mark left in Spain by Luca Giordano was carried on in the court of
Ferdinand VI and Charles III, first by Amiconi and, on his death, by
Corrado Giaquinto, who culminated the work of his predecessors.
Contemporary with Giaquinto and the spectacular and religious Baroque
style that he represented, a Genoese artist, Alessandro Magnasco,
appeared in Italy. He brought an original aesthetic concept
that reveals a certain expressionist tendency.

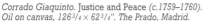

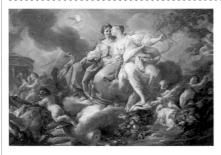

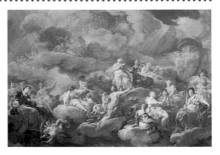

Corrado Giaquinto. Justice and Peace (c.1759–1760). Oil on canvas, 126³/₄ × 62³/₄". The Prado, Madrid.

Corrado Giaquinto. Glory with Saints (1754). Oil on canvas, 53¹/₂ × 37³/₄". The Prado, Madrid.

Corrado Giaquinto

The Work of Giaquinto in Spain

Giaquinto was, above all, a painter of allegorical and biblical themes, which revealed his profoundly religious nature, in the triumphant style of the time. His style, a mixture of fantasy and extreme dramatism, may claim a certain Rococo taste with its

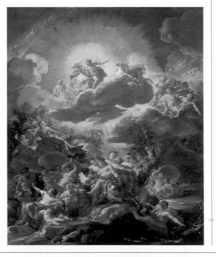

Corrado Giaquinto. Birth of the Sun and Triumph of Bacchus. Oil on canvas, 54¹/₂ × 65¹/₂". The Prado, Madrid. Giaquinto is one of the most brilliant creators of seventeenth-century allegorical painting. His artistic inheritance from Luca Giordano together with his solid training by Solimena enabled him to undertake great pictorial works.

flowing brushwork and gallant poses, so peculiar to the Baroque style of the eighteenth century.

For the Conversation Room in the Royal Palace of Aranjuez (currently the official dining room), he painted a series of mural frescos on the life of the biblical figure of Joseph: *Joseph Interprets the Dreams in Prison, The Cup in Benjamin's Sack, The Triumph of Joseph* and *Joseph*

Presents His Family to the Pharaoh. These paintings were to complete the pictorial decoration of the room, originally started by Amiconi.

For the dome of the chapel of the Royal Palace in Madrid, he painted *The Holy Trinity* in which a multitude of worshippers advance in concentric circles, from the bottom of the dome to the zenith, where the Holy Spirit is depicted. A representation of the Virgin Mary underneath Jesus stands out with the blue folds of her tunic.

He produced eight outstanding easel works (now in different museums), which he painted for the king's oratory in the Buen Retiro Palace: *The Holy Trinity with All the Saints, The Praetorium of Pilate, The Flagellation of the Lord, The Crown of Thorns, Christ with the Cross, Descent, The Prayer in the Garden* and *The Holy Face.* Another series of lesser quality paintings appeared in the queen's oratory.

Another noteworthy series of allegorical paintings are to be found in the Casita del Príncipe in El Escorial *(Venus and Adonis,*

THE ARTIST'S LIFE

1703. Corrado Giaquinto is born in Naples. He worked as a disciple of Solimena before moving to Rome where he worked on the *Frescos of Santa Cecilia in Trastevere*.

1752. He leaves Italy and settles in Madrid, summoned by Ferdinand VI of Spain, to replace Armiconi (1675–1752), on the decoration of the Reales Sitios. Upon his arrival in Spain he is named chamber painter and director of the Academy of Fine Arts of Saint Ferdinand of Madrid. He is also officially appointed the supplier of cartoons to the Real Fábrica of Tapices of Santa Barbara. He devotes the latter years of his artistic life to decorating the Royal Palace in Madrid during its construction.

1762. He receives Charles III's permission to depart Spain and live for six months in Naples, a city he was never to leave because of ill health.

1766. He dies in Naples.

Apollo and Daphne, Hercules and Virtue) and others in the Palace of Aranjuez *(Religion and Abundance, Prophesy and Providence).*

Alessandro Magnasco. The Synagogue *(1734–1749). Oil on canvas, 58¹/₄ × 46¹/₂". Cleveland Museum of Art, Ohio. Magnasco's painting is difficult to interpret, shrouded, as it is, in a halo of fantasy and mystery. His elongated figures have a ghostly air about them, reminiscent of El Greco.*

Alessandro Magnasco: The Strange Painting of an Artist "Not of His Time"

In the same way that El Greco possessed a "different" personality within Spanish Baroque painting, the Genoese Alessandro Magnasco (1667–1749), called Il Lissandrino, was the exception to the overall tendency of eighteenth-century Italian Baroque paintings. His painting has been associated, somewhat conventionally, with the School of Naples.

His style of painting is macabre, phantasmagoric, with elongated, stylized figures that are reminiscent of the disproportionate figures of El Greco, shrouded in a tenebrism that makes use of dark ochres and strange, almost ghostly illumination. Magnasco's paintings are always disturbing, full of hidden themes parallel to the main subject. As occurs with other artists difficult to classify, his paintings reflect his most intimate anxieties.

His unusual scenes *(The Synagogue* and *Evening in a Garden in Albaro*, for example), his gatherings of monks, grotesque demons, and street scenes, all lose any sense of normality and appear to express the rather sinister, inner world of the artist. Magnasco's sketching technique, with nervous, steady brushstrokes and a leaning toward caricature clearly situate his painting in an expressionist tendency.

Piranesi: An Original Engraver of the Eighteenth Century

Giambattista Piranesi (1720–1778), Venetian by birth, was one of the greatest engravers of all time. In the context of the eighteenth century, his work, like that of Magnasco, can be considered to be "not of his time." His strong liking for poetic evocation is characteristic of Romanticism. In his 137 *Vedute di Roma* (views of Rome), the

Piranesi. Carceri d'Invenzione. *Engraving, Uffizi Gallery, Florence. His outstanding skill as an engraver (he was a true "Michelangelo" of engraving) can be seen in the fantasy used for his series of "imaginary prisons," which seem taken from a dream world.*

Roman ruins take on a deformed character, like that of enormous, one-eyed masses, powerful giants, as if it were a world inhabited by semi-gods. However, his fantasy reaches its height in the *Carceri d'Invenzione* (prisons). These are monstrous, underground prisons, with attributes pertaining to a surrealistic dream world.

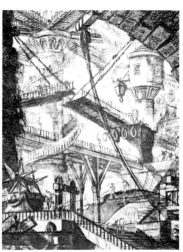

TIÉPOLO

It was during the second half of the eighteenth century that Baroque Italian painting reached its utmost degree of expansion thanks to the works of the Venetian Giambattista Tiépolo. The most outstanding domes in European palaces bear witness to the extraordinary skill of Tiépolo for fresco murals, with their hitherto special coloring and daring drawings. Tiépolo was the last of the great Venetian and Baroque Italian painters.

His Forerunners

Sebastiano Ricci and Giovanni Battista Piazzeta

These painters revitalized the Venetian painting of the eighteenth century. Sebastiano Ricci (1657–1734) freed color from the darkness of the early Baroque, while Giovanni Battista Piazzeta (1682–1754), trained in the Neapolitan school, succeeded in creating a painting of intense shadows, with a beautiful blending of spontaneous brushwork, and an almost "modern" touch. Both prepared the way for Giambattista Tiépolo.

Tiépolo's Works

Influences

Within the context of undeniable dramatism of Venetian painting, Tiépolo's strong personality set him aside from his contemporaries. His stylistic coincidence with his predeces-

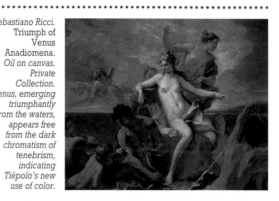

Sebastiano Ricci. Triumph of Venus Anadiomena. Oil on canvas. Private Collection. Venus, emerging triumphantly from the waters, appears free from the dark chromatism of tenebrism, indicating Tiépolo's new use of color.

Among his vast production of frescos we may mention:

Scene from the Old Testament (1727–1728). Palace of the Archbishop of Udine, Italy.
Scenes from the Aeneid and the Odyssey, frescos at Villa Valmarana, near Vicenza, Italy.
Story of Anthony and Cleopatra, in the Labia Palace, Venice.
The Race of the Sun in the

Universe, in the Clerici Palace, Milan.
The Four Quarters of the World, on the staircase of the Neumann Residence, Würzburg, Franconia.
Apotheosis of the Spanish Monarchy and *The Apotheosis of Spain,* in the Royal Palace, Madrid.

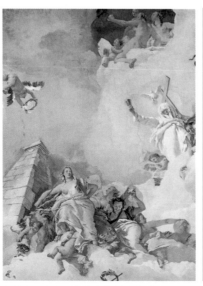

Giambattista Tiépolo. The Apotheosis of Spain, fragment (1662–1664). Large fresco, 35 × 91', ceiling of the throne room in the Royal Palace, Madrid. The chromatic and formal solutions in search of space are truly brilliant. The painting requires a zenithal vanishing point which, in turn, demands pronounced foreshortening. This allegory represents the glorification of the Spanish monarchy attended to by the virtues and surrounded by the states.

sors and the great Renaissance masters is purely occasional. By his emphasis on the ornamental and exotic dress of his characters and his fondness for architecture, Tiépolo's work is sometimes reminiscent of Veronese.

Tiépolo can be considered the last of the great mural painters in Venice, a true successor of Veronese and Tintoretto.

Characteristics of Tiépolo's Painting

Tiépolo's construction of unreal scenes, of gatherings of characters, such as country folk, clowns, and allegorical figures, are painted from most unusual angles. The characters in his fresco painting seem to appear on platforms, upon plinths, or carried away by clouds.

In Tiépolo's work, cerulean tones clearly dominate and they pleasantly contrast with the warm tones. He never uses vivid tones and uses light over light and glaze over glaze. Tiépolo moves away from the Classical-Renaissance solidity toward a particular type of polychrome, based on the juxtaposition of complementaries.

Tiépolo's pictorial technique is quite extraordinary. The way he studies forms as if they were large planes of light, penumbra, and shadow, with hardly any gradations,

Giambattista Tiépolo. The Charlatan (1756). Oil on canvas, 42 1/2 × 31". Cambó donation, National Art Museum of Catalonia, Barcelona. Taken from the Papadopoli Palace, Venice, it is a fine example of the Venetian's easel painting,

together with his nimble brushwork on the highlights, reveal how accurately the artist could foresee the formal and chromatic effect that distance produces.

Tiépolo's Works

His works cover a wide, varied range. Among his easel works we might mention *The Charlatan*, a street scene with peculiar characters, one that is not without oriental references. One version is held in the Louvre, Paris, and another in the National Art Museum of Catalonia (Barcelona). Another important work is in the Prado: *Abraham and the Three Angels*, depicted against a landscape. It is a fine example of how Tiépolo's easel painting abides by the same aesthetic nature which guides his mural style.

Giambattista Tiépolo. Study for The Miracle of the House of Loreto. Oil on canvas, 33 × 48 1/4". Accademia, Venice. In this study for the fresco of the church of the Scalzi in Venice, destroyed during the First World War, Tiépolo organizes the figures in four tonal areas that are gradated into the sky-blue background.

THE ARTIST'S LIFE

1696. He was born in Venice, to a wealthy family.

1715. A precocious master, at the age of 19 he begins his career as a painter with a tendency toward tenebrism, as shown in his *Madonna of Carmelo*, Brera Art Gallery, Milan.

1726–1728. Tiépolo works in Udine. In his painting for the fresco of the Archbishop's Palace, the style of the young artist already displays the predominating features of his later works.

1731–1762. His fame spreads throughout Europe and, for thirty years, his paintings fill the most renowned palaces of the time with light and fantasy: Milan (1731), Venice (1747–1750), Vicenza (1753), Verona,

Bérgamo, etc. Between 1750 and 1753, he decorates the residence of the architect J. Balthasar Neumann, in Würzburg, Bavaria.

1762. He arrives in Spain, summoned by Charles III to decorate the throne room in the Royal Palace in Madrid.

1770. He dies in Madrid.

THE GREAT VENETIAN VEDUTE: CANALETTO AND GUARDI

During the seventeenth century, The Grand Tour became popular. It included sojourns in major cultural and artistic centers by artists, intellectuals, traders and, in general, the higher classes. Venice was one of the cities to arouse the most interest, not only for its artistic values, but also as a major trading center. This "tourism," which continued throughout the eighteenth century, exalted a certain type of painting: the *vedute* (scenes or urban landscapes), which, with Lucas Carlevaris (1665–1731) reached a high artistic level.

Antonio Canal, Canaletto

Canaletto's Paintings

From the school founded by Carlevaris, specialized in *"vedutisti,"* emerged one of the greatest painters of urban scenes. His works, present in the finest art collections, place him among the most prestigious Baroque artists.

Italian *vedutisti* has its antecedent in the Dutch painters of buildings. The first of these painters would seem to be van der Heyden, because of the similarity in theme and treatment, although Canaletto had a more advanced technique and a greater command of perspective.

Canaletto was born in Venice in 1697 and during his early years as an artist, studied perspective with his father, Bernardo Canal, a discipline that he was to master.

In 1719, in Rome, he executed different backcloths for operas by Scarlatti and painted several

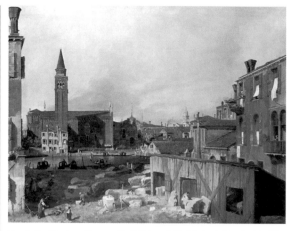

Canaletto. Venice: Campo S. Vidal and S. Maria della Carità (The Stonemason's Yard). *Oil on canvas, 63 1/2 × 48 1/2". National Gallery, London.*

scenes in which antiquity is the protagonist.

The work of Pannini, a painter who specialized in depicting ruins and whom Canaletto met in Rome, and the influence of Lucas Carlevaris, inspired him to make the decision to devote himself to

painting *vedute*, a specialty in which he was far superior to most of the other architectural painters of the time, given the accuracy of his drawing, the wealth of color, and his extraordinary capacity to capture the light of the sky and the Venetian canals.

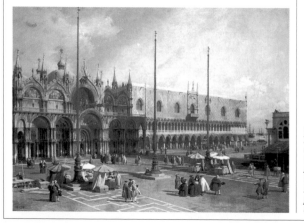

Canaletto's paintings were executed when Venice was becoming aware of its beauty.

Canaletto. The Square of Saint Mark's Venice *(1742–1744). Oil on canvas, 60 1/4 × 45 1/8". National Gallery of Art, Washington, D.C. A theme used by the artist several times, in which he could delight in his extraordinary gift for perspective, both in linear and atmospheric terms.*

THE ARTIST'S LIFE

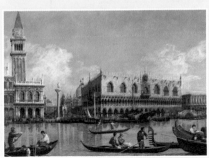

1697. Antonio Canal (Canaletto) was born in Venice.
1719. He decides to become a painter of urban landscapes *(vedute)*.

1725–1726. He works for Stefano Conti from Lucca.
1728. He travels to England on the invitation of the Duke of Richmond. The city scenes he painted there are among his best works. Without leaving aside his use of perspective and fondness for detail, his painting becomes more fluent.
1746 and 1751. The city of London, which he revisits, becomes the best market for his paintings and engravings. Canaletto's fame spreads throughout the whole of Europe, and his work is highly prized, partly because he would often engrave his paintings himself. Toward the end of his life, Canaletto's work becomes more routine and mechanical.
1768. He dies in the city of his birth, recognized as the best Venetian landscapist.

Francesco Guardi

Summary of His Life and Works

He was born in 1712 into a family of painters. This tradition had a profound influence on his life. He devoted himself to his work, without any apparent desire to become famous.

He was a refined, lyrical painter who interpreted his city in a profoundly poetical manner.

He was trained in the studios of Marieschi and Canaletto and was the brother-in-law of Tiépolo, who had married one of his sisters. His work, however, went unnoted until well into the eighteenth century. He was only rediscovered with the appearance of French Impressionism.

Francesco Guardi. View of the Grand Canal in Venice. Oil on canvas, 21⁷/₈ × 29¹/₄". Pinacoteca di Brera, Milan. Guardi's small format landscapes constitute a form of urban "portrait" in which the artist uses a pictorial technique tending toward Impressionism.

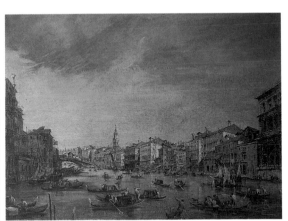

Above, in the box, Canaletto. The Quay of Saint Mark. *Oil on canvas, 25⁵/₈ × 27¹/₄". Pinacoteca di Brera, Milan.*

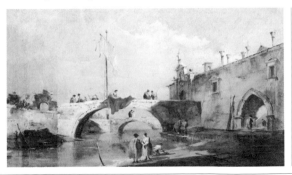

Left. Francesco Guardi. Landscape with Bridge. *Oil on canvas, 11³/₄ × 20⁵/₈". Uffizi Gallery, Florence. A fine example of Baroque Venetian urban landscape by a first-class artist who devoted his life to his work like a true craftsman.*

ROSALBA CARRIERA

The Venice of the eighteenth century was no longer the city of importers and exporters who made fortunes with which they transformed their city-state into a unique place. During the eighteenth century, Venice became a city devoted to leisure, and artistically, its "ornamental" style lived on the fame of its past masters, led by Tiépolo. Its art did not reflect the genuine Venice where figures from all walks of life mingled. On this scene appeared a woman who was unique in Baroque art: Rosalba Carriera, an exception for a woman of the time, who was recognized as one of the great artists of Europe. From her youth it was obvious she was an artist destined to take painting from its traditional past to the real Venice.

Rosalba Carriera's Painting

Carriera chose to paint in pastels. This was a most fortunate choice, as pastels afforded the artist the characteristics necessary for her work: elegance, tenderness, spontaneity, and a certain erotic insinuation which revealed a Rococo tendency.

Her extraordinary mastery of this technique is apparent in the silky quality of her light effects, the use of light tones, the quality of her flesh-colors with a kind of unreal halo similar to Leonardo's *sfumato*.

Rosalba Carriera. Young Man from the Leblond House. *Pastel on paper, 13¹/₄ × 14³/₈". A popular portrait painter, Carriera knew how to paint in a style that pleased the high society. Yet the delicate look on the face of this adolescent shows that her painting was more than fashionable; it was professional and sensitive.*

Rosalba Carriera's painting was a reflection of passionate femininity, tempered only by the need to appear gentle.

To find a husband for Rosalba Carriera would mean resuscitating Guido himself.

G.M. Crespi

Rosalba Carriera. Flora. *Pastel on paper, 9 × 18³/₈" Uffizi Gallery, Florence. The gentle atmosphere that surrounds this portrait and the sfumato that blurs the outlines and the misty colors (highly appreciated by the Rococo), make it a prototype of Carriera's poetic feminism.*

The Great Venetian Vedute: Canaletto and Guardi
Rosalba Carriera
The Great Century of France. Simon Vouet

35

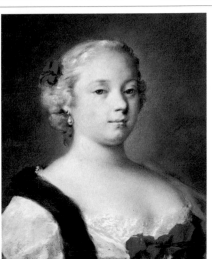

Rosalba Carriera.
The Ballerina Barbarina Campani.
Pastel on paper, 18 1/8 × 22". Painting Gallery,
Dresden. Pale, velvet-textured flesh colors,
surrounded by Spanish lace and pearls, for one of the
most outstanding pastel paintings in the history of art.

Rosalba Carriera. Carlota Gauthier. Pastel on paper,
19 1/2 × 15 5/8". Accademia, Venice. As a pastel
painting, this is one of the flattering portraits painted
by the artist. Details of the dress and adornments show
Carriera's creativity as diverse pictorial solutions.

Rosalba Carriera's work is on display in several of the greatest museums in Europe, although most of her portraits are kept in the Dresden Art Gallery. The Uffizi Gallery in Florence has her *Self Portrait*, which was commissioned by Duke Cosme II of Bologna. Turin Museum, the Louvre, the Hermitage in Saint Petersburg, as well as museums in Copenhagen, Vienna, and others all display works by this unique painter of the Italian Baroque.

THE ARTIST'S LIFE

1675. Rosalba Carriera was born on October 7th of this year in Venice, into a bourgeois family. In her early years, she was a disciple of the painters G. A. Lazzari, Giuseppe Diamantini, and Antonio Balestra.

1700. The painter and engraver of the Bologna School, Giuseppe Maria Crespi (1665–1747), has the occasion to know Carriera's works and becomes an enthusiastic benefactor.

1703. She wins special membership in the Academy of St. Luke in Rome, which confirmed her as a great artist.

1703–1716. She takes a studio located on the Grand Canal, near the Venier Palace, where she is visited by princes and other important personalities traveling through Venice.

1716. The French collector Pierre Crozat, treasurer to the king of France, convinces her to move to Paris. Here she meets Watteau and has the opportunity to paint the portrait of the young King Louis XV.

1720. Her work becomes even more appreciated, and she is admitted into the French Academy.

1730. Back in Venice, after passing through the court of Modena and visiting Vienna, where she was acclaimed. She makes several visits to Dresden.

1746. Her activities virtually cease as she becomes blind. Her sight is temporarily restored by an operation but lost permanently in 1749.

1757. Mentally disturbed, she dies on April 15th.

THE GREAT CENTURY OF FRANCE.
SIMON VOUET

The 17th century, under the reign of Louis XIV, has been called the Great Century of France. Its most abundant works occurred during the times of cardinals Richelieu and Mazarin. It was at this time that Simon Vouet brought a new fashion into official painting in France. He abandoned Mannerism for Baroque painting, which blends Classicism, Naturalism, and the academic.

Influences

Simon Vouet is the first painter of the Bourbon era to rise above mediocrity.

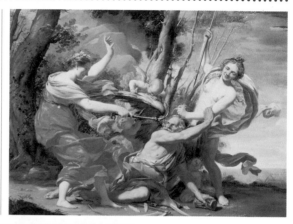

Simon Vouet. Time Conquered by Love, Hope, and Beauty *(1627). Oil on canvas, 55³/8 × 41³/4". The Prado, Madrid. This is one of Vouet's most well-known paintings, with its classically inspired theme and the formal derivation of the Italian style that Vouet introduced to early Baroque French painting.*

He formed his style in Italy (1612–1627). Vouet's works from that period show his great admiration for Caravaggio. Tenebrist realism is present in his work, which is basically religious.

Later he took up the eclecticism of Guido Reni, another of the masters who influenced him most directly. Vouet's painting moved away from Classicism toward a certain blending of styles, representative of the crossroads at which French painting stood at the start of the seventeenth century.

Simon Vouet. The Penitent Magdalene. *Oil on canvas, 66³/8 × 67⁷/8". Amiens Museum, France. This painting, in the best Classicist style, is a fine example of Vouet's religious painting, showing an excellent use of tenebrism.*

The architect and historian André Félibien (1619–1695) stated that "we should be grateful to Vouet for having revived fine painting in France."

Noted religious works by Vouet are:

The Birth of the Virgin, church of San Francesco a Ripa.
The series on the *Life of Saint Francis* (1629), church of San Lorenzo in Lucina.
The Penitent Magdalene, in Amiens Museum. An oil painting showing a heavy influence of Caravaggio.
The Annunciation (between 1614 and 1621), in the Kaiser Friedrich Museum, Berlin.
His most outstanding Classicist paintings include: *Apollo and the Muses,* Budapest Museum; *Time Conquered by Love, Hope, and Fame,* Berry Museum, Bourges; *The Death of Dido* (c. 1641), Dole Municipal Museum, France.

THE ARTIST'S LIFE

1590. He is born in Paris, the son of the painter Laurent Vouet. He starts to work with him and soon reveals himself to be a child prodigy.

c.1604. Only 14 years old, he is considerably famous, to the extent that he is summoned to London to paint the portrait of an English lady. King Charles I tries to retain him at the court.

1611. Vouet travels to Constantinople as companion to the ambassador of France, Baron de Sancy. There he paints from memory the portrait of Sultan Ahmed I, whom he had only seen once.

1612. He travels to Italy and settles in Venice where he becomes acquainted with the work of Titian and Veronese. It influences him greatly as the work of Caravaggio had when Vouet saw it in Rome. During his long stay in Italy, he produces numerous works and receives many distinctions. In Rome he is appointed president of the Academy of St. Luke.

1627. He returns to Paris, summoned by Louis XIII who assigns him a pension, appoints him first painter of the court and provides him with accommodation in the Louvre Palace. He receives and executes a large number of commissioned works.

1649. Death of Simon Vouet.

In Paris, Vouet assimilated details of the Flemish school to which several Walloon masters who worked in France belonged, without forgetting the influence of other artists such as the Le Nain brothers.

The fame, glory, and fortune achieved by Vouet is greater than that of any other French painter. Paradoxically, he was quickly forgotten by those who had admired him. It was King Louis XIII himself who led to his decline when, after examining a work by Poussin, exclaimed: "Voilà Vouet bien attrapé!"

Vouet's painting introduced nothing new into European Baroque painting. However, the Baroque Italian style he introduced into official painting, dominated by mediocre artists, represented a truly novel approach that influenced the younger French artists: Perrier, Le Sueur, Mignard, Le Brun, etc.)

Vouet's Work

Vouet left behind an enormous body of work, first in Italy and in France, where his early paintings, most religious for the most part and in the style of Caravaggio, gave way to a much more Classicist style applied to themes of a mythological or legendary nature.

Simon Vouet. Prince Marcantonio Doria. *Oil on canvas, 37 × 50³/₈". Louvre, Paris, anonymous donation in 1979. The presence of Caravaggio during Vouet's Roman period is more than apparent in this portrait.*

Vouet's fame was as great as it was short-lived, and this resulted in the disappearance of the works he had painted while decorating palaces and churches: the Doria Palace in Genoa, the Louvre, the Luxembourg, the Palais-Cardinal, the Palace of Richelieu, at Rueil, the Gallery of the Bullion Hotel and Chilly Castle, as well as the churches of Saint Merri, Saint Eustache, and Saint Nicolas des Champs, among others.

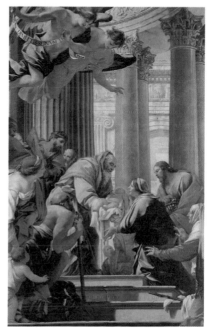

Simon Vouet. The Presentation in the Temple *(1641). Oil on canvas, 97¹/₂ × 153¹/₄". Louvre, Paris. This fine oil painting was executed for the main altar in the Jesuit church of Saint Paul-Saint Louis in Paris.*

THE GREAT CENTURY OF FRANCE.
PHILIPPE DE CHAMPAIGNE AND REALISM

We have said that French painting in the seventeenth century ranged between the Classicist tendency, the Baroque, and the rules laid down by the French Academy of Painting and Sculpture. Nevertheless, the work of Philippe de Champaigne, cofounder and teacher at the Academy, and therefore one who established the academic rules, added a third tendency: naturalist realism, in the tradition of Flemish painting. Yet these aesthetic characteristics of French painting belonged entirely to the painting of Champaigne and disappeared with him.

Influences

The figure of Philippe de Champaigne is a unique case in French Baroque painting of the seventeenth century: he was from Brussels, one of the countries with the greatest pictorial traditional in the world, and despite having lived in France from the age of nineteen, his painting reveals that the pictorial tradition of the low countries had left an indelible mark on him.

Although he declared his admiration for Poussin and his academic Classicism, Champaigne's pictorial world was that of naturalist realism.

This search for realism led him into an academic debate with Le Brun, considered "the master" of the academics, something which today appears absurd to us. Champaigne reproached Poussin for not having included the camels mentioned by the

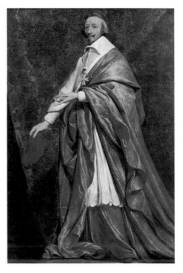

Philippe de Champaigne. Cardinal Richelieu (1635), Oil on canvas, 60³/₈ × 86¹/₂". Louvre, Paris. His Flemish roots can be seen in this portrait of elegant realism. The sober colors, extraordinary brilliance, and the perfect use of chiaroscuro that models the sculpturelike folds form part of the Flemish tradition.

Bible in the episode in which Rebecca meets Eleazar at the well. Le Brun defended Poussin. Apart from the "Flemish" thoroughness with which he treated detail, Champaigne's realism is incompatible with supernatural visions. He has no time for gratuitous scenes.

Characteristics

Champaigne's painting is austere and, at the same time, emotive, when dealing with themes that reflect states of mind or highly subjective feelings. In his religious works, he is the French painter who comes closest to bare reality. In his official works, mostly commissioned by Louis XIII and Cardinal Richelieu, he shows his mastery of color and the effects of light, in carefully balanced compositions that are reminiscent of Rubens.

Philippe de Champaigne. Louis XIII Receives the Duke of Longueville in the Order of the Holy Spirit (1634). Oil on canvas, Museum of Fine Arts, Troyes, France. Group portrait, executed with detailed realism.

The Great Century of France. Simon Vouet.
Philippe de Champaigne and Realism
Nicolas Poussin and Georges de La Tour

39

His respect for the Flemish tradition can also be seen in the extraordinary clothing worn by many of the persons depicted, with complicated, sculpturelike folds, painted with the same attention to detail as the great masters of Flanders and Holland, without any spectacular effects of gratuitous ostentation. In Champaigne's painting, luxury corresponds to real situations and people, with-out any of the added effects treasured by the Baroque.

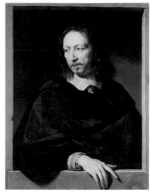

Philippe de Champaigne. Portrait of a Man. *Oil on canvas, 28 × 37⁷/₈". Louvre, Paris. After becoming involved with Jansenism in 1640, he rejected the Baroque style in his works.*

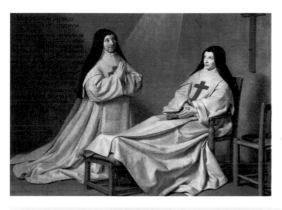

Philippe de Champaigne. Ex Voto *(1662). Oil on canvas, 89³/₈ × 64³/₈". Louvre, Paris. An example of his sober realism, painted in thanks for the miraculous cure of his daughter.*

THE ARTIST'S LIFE

1602. He was born in Brussels, the city where he started his studies and which he left to go to Antwerp and work with Rubens, whom he admired throughout his life.

1621. Attracted by Italy, he sets off and passes through Paris. The atmosphere in the French capital entices him to abandon his original plan and settle there.

1630–1640. Champaigne is appointed painter to Queen Marie de Médicis and valet to the king, taking up his residence in the Palace of Luxembourg. He receives the first commissions from the king, including the decoration of the Carmelite church, in which he alternates mural paints with large easel painting in oil. This is the period of his early religious works and his most well-known portraits of famous personalities; individuals, or groups, during the celebration of important ceremonies.

1640. Champaigne, who had become involved with Jansenist doctrines and the abbey of Port-Royal, evolves toward austerity and emotionality, as can be seen from the series of works painted for the abbey.

1648. Champaigne forms part of the board of founding artists of the Royal Academy of Painting and Sculpture in France. The same year, he paints one of his finest group portraits, *The Council of the City of Paris.*

1653. He is appointed professor of the Royal Academy.

1662. On January 6th of this year, his daughter Catalina, a Carmelite at Port-Royal, is suddenly cured of a long-lasting fever after praying fervently to God. The importance of this date for French painting lies in the painting the artist executed for the convent of Port-Royal, as a sign of thanks. It is an example of the finest realism of all time, austere and senti-mental at the same time. We refer to the work "Ex Voto" *Mother Agnès Arnauld and Sister Catalina,* today in the Louvre.

1674. Champaigne painted up to his death, in 1674, which came shortly after painting another group portrait for Louis XIV: *Reception of the Duke of Anjou into the Order of the Holy Spirit,* in the cathedral at Reims. This was a theme that Champaigne had already painted: *Louis XIII Receives the Duke of Longueville into the Order of the Holy Spirit* (1634, Museum of Fine Arts, Troyes, France.)

BAROQUE PAINTING IN FRANCE

NICOLAS POUSSIN AND GEORGES DE LA TOUR

The painting of the Great Century of France had extraordinary painters who moved away from the "orthodoxy" of contemporary official art. This was the case of two very different painters, whom we shall study in this chapter: Nicolas Poussin and Georges de La Tour. Some historians challenge Poussin's belonging to French Baroque painters because of his long stay in Rome that isolated him from the official art of France.

Nicolas Poussin

Influences

It has been said that Poussin was a Renaissance artist who assimilated the poetry of Hellenic antiquity into the world of the Baroque. In Rome, he came under the influence of Domenichino, who shaped his aesthetic ideals, although Veronese's mark is also felt.

The pictorial world of Poussin, peopled by gods and heroes, was inspired by Domenichino and the Renaissance painters and fueled by the reading of the ancient texts and the study of Roman monuments. It is possible that the Roman fresco *The Aldobrandina Wedding*, discovered in 1606, which Poussin admired and studied, also had an influence on his Classicism. Poussin's painting was very thoughtful and completely honest. He studied his composi-

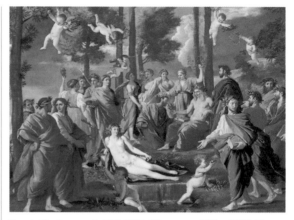

Poussin. The Parnasse (c.1626–1635). Oil on canvas, 76 7/8 × 56 1/2". The Prado, Madrid. The best example of the painter's Classicist obsession.

tions using wax figures that he illuminated inside a dark room, experimenting with the angle of light until he had found the best effect.

With Poussin, more than the form and more than the color, the light is the means of expression that defines his work.

Poussin. The Inspiration of the Epic Poet (c.1630). Oil on canvas, 83 1/2 × 71 3/4". Louvre, Paris.

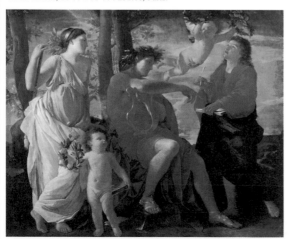

Poussin. Self Portrait (1650). Oil on canvas, 28 7/8 × 38 1/4". Louvre, Paris. Poussin expresses himself more through light than through form and color.

Philippe de Champaigne and Realism
Nicolas Poussin and Georges de La Tour
The Academic Tendency. Le Brun

41

THE ARTIST'S LIFE

1594. Nicolas Poussin is born, the son of a simple soldier and Maria Delaisement, the widow and daughter of a farmer. He spent his childhood on a farm in Villers near Paris and in the collegiate church of Grand Andely, where he received a good education.

1612. Poussin moves to Paris, where he studies the royal collections and the engravings of the works of Raphael made by Raimondi.

1620. He makes his first trip to Rome, although for unknown reasons he then returns to France. In Paris he comes into contact with Philippe de Champaigne and the Italian poet, Marino, for whom he paints illustrations.

1624. Poussin settles definitively in Rome, recommended by Marino to Cardinal Barberini,

nephew of Urban VIII.

1628. The cardinal commissions the work *The Martyrdom of Saint Erasmus*, for St. Peter's Basilica, a work much influenced by Domenichino. *The Triumph of Flora* (Louvre, Paris) with clear Venetian connotations and *The Parnasse* (The Prado, Madrid) also date from this time. They are paintings in which Poussin shows his detailed compositions, as well as his fondness for, and mastery of, the landscape.

1630. Poussin gradually perfects Classicist style, as can be seen in his works *Inspiration of the Epic Poet* and *The Plague of Asdod*, both in the Louvre Museum.

1640. After great resistance, he travels to Paris summoned by Louis XIII, who appoints him the king's first painter. But the excess of commis-

sions that choke his creative capacity and the jealousy from other artists cause him too many problems, and he returns to Rome two years later.

1635–1650. Poussin combines Classical themes and religious themes in compositions that show his perfectionism: *The Rape of the Sabine Women*, 1635 (Louvre, Paris), *Moses Saved from the Waters*, 1638 (Louvre, Paris), *The Holy Family*, 1648 (National Gallery of Art, Washington, D.C.), *Landscape with Polyphemus*, 1649 (Hermitage), and *The Shepherds of Arcadia*, 1650–1655 (Louvre, Paris).

1665. He dies in Rome, where he had settled after his failed adventure in Paris.

Georges de La Tour

A Singular Tenebrism

Georges de La Tour (1593–1652) was the son of a baker in Metz who never had the slightest connection with art. A contemporary of Vouet, it suffices to compare the two artists to see how singular de La Tour's work is completely removed from the fashion of the period. Despite enjoying royal protection, he always lived outside the court. It has been said that . . .

. . . de La Tour's painting, in line with the spirit of Caravaggio, is a study of the human soul.

He did not paint many works. He had about 75 paintings, between "daylight" works and tenebrist works, of which only 35 originals have survived. The daylight works possess a cool light, which causes the figures to pale. The tenebrist paintings (his most well known and admired)

have a single point of light, a candle or a torch, so that everything is depicted in accordance with the light source. This effect hardens the features, unifies the color, and flattens the volumes; nevertheless, it produces an essential realism, without additional figures or architecture.

Noted works are his *Saint Jerome* (Grenoble Museum), the series *Christ and the Apostles* (Toulouse-Lautrec Museum, Albi), and his tenebrist paintings, *Saint Sebastian tended by Irene* (chapel of Bois-Anzeray, in Eure, France), *Saint Joseph the Carpenter* (Louvre, Paris), etc.

Georges de La Tour Saint Sebastian tended by Irene (1649). Oil on canvas, 51 × 65¹/₈". Louvre, Paris. This painting, discovered in 1945, is a fine example of de La Tour's original use of tenebrism. The light source in this case is the torch the saint is holding.

THE GREAT CENTURY OF FRANCE.
THE ACADEMIC TENDENCY. LE BRUN

The preponderance of the academic attitude in the painting of the Great Century coincided with the reign of Louis XIV. The absolute monarch who said "L'État c'est moi," had his own private dictator runing over artistic matters, Charles Le Brun. No other artist has enjoyed the total confidence of the most powerful king of the time, to organize and place great artists at the service of his ideas. Thus, in architecture, specifically the Palace of Versailles, he was the inventor of the so-called "French order," while in decoration and painting, his influence over other artist shaped the Louis XIV style.

Le Brun's Style

Le Brun's style seems to have appeared merely to please the powerful. It has been said that he took his colors from Titian and Veronese, his composition from Raphael, the decorative talent of the Carracci brothers, and the dramatism of Italian opera. These are the bases for the "academic ordering" of his compositions.

However, his easel works appear to belie his academic persuasion, especially in his portraits, in which Flemish reminiscences appear, with the distinguished elegance of van Dyck, although Le Brun systematically attacked him in his classes.

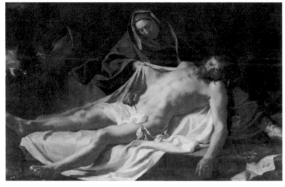

Charles Le Brun. Pietà (1643–1645). Oil on canvas, 86¹/₂ × 57". Louvre, Paris. This work, executed in a scrupulous formal academic manner with many tenebrist references, produces a strong emotional impact.

Charles Le Brun. Alexander and Porus (right half of painting), displayed in the Salon in 1673. Oil on canvas, total measurements 493 × 183³/₈". Louvre, Paris. It formed part of Louis XIV's collection.

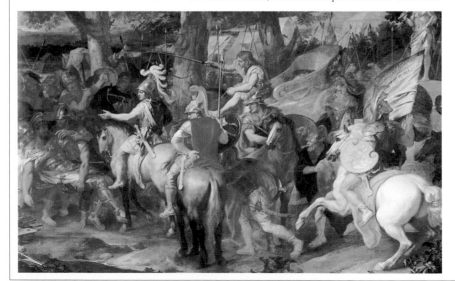

Nicolas Poussin and Georges de La Tour
The Academic Tendency. Le Brun
The Ruralism of the Le Nain Brothers

43

Le Brun's Works

The Palace of Versailles, a true symbol of the Great Century of France, houses the most representative works of Le Brun as a decorative painter: the *Hall of Mirrors*, the *Apollo Room*, the *Peace Room*, and the *War Room* are the result of his superb planning and supervision and were exquisitely executed and painted. The *Ceiling of the Hall of Mirrors* is a magnificent example of his ability as a fresco painter.

The sculptures at Versailles were also executed according to Le Brun's instructions, and the groups of sculptures carved for the park fountains were created according to his drawings.

For the Royal Tapestry Manufacture of the Gobelins, he painted series of cartoons. Among the most important sets he designed were *The Royal Residences* and *The Life of Louis XIV*.

The Story of Alexander the Great, according to Quinto Curcio (1660–1668) is one of the series of canvases which are most representative of Le Brun's "Louis

Charles Le Brun. Chancellor Séguier *(1655–1657). Oil on canvas, 136-7/8 × 115". Louvre, Paris. The distinction and elegance of van Dyck's style discernible in this work reveal certain Flemish influences.*

XIV Grand Manner" art. It comprises five scenes: *The Passage of the Granico, The Battle of Arbela, The Tent of Darius, Alexander and Porus,* and *Alexander Entering Babylonia*. This latter painting, a large canvas measuring $275^{3/4} \times 175^{1/2}$", is on display at the Louvre Museum.

His Portraits. Among his vast production of portraits, we should mention the following because of their special importance in revealing his "academic" tendencies, *Chancellor Séguier* (1655), in the Louvre Museum, and *Louis XIV Adoring Christ Resurrected* (1674), in the Lyon Museum.

THE ARTIST'S LIFE

1619. He is born in Paris, the son of a sculptor. He began to learn drawing from François Perrier and finished his early training in Simon de Vouet's studio.

1639. He visits Rome for the first time.

1642. Under the protection of Séguier, he again visits Rome where he stays for four years. This is the period which defines his style as a painter. Back in Paris, he mixes with the most influential people of his time: Lambert, president of the National Audit Authority, the queen mother, Fouquet, Colbert, and, finally, Louis XIV himself.

1648. He cofounds the Royal Academy of Painting and Sculpture with Champaigne and other artists. He is appointed director.

1649. Fouquet, during the regency of Anne of Austria, entrusts him with the supervision of the painting and sculptures of Saint Mandé and Vaux-le-Vicomte, a task that allows him to demonstrate his extraordinary ability for decorating and organizing teams of artists.

1660. He receives a royal commission: to paint five compositions on the life of Alexander the Great, a theme that fascinated Louis XIV.

1662. Colbert, successor to Fouquet, appoints him director of fine arts, while he remains, at the same time, painter to the king, who saw in his work the finest artistic expression of the kingdom. He bestowed many honors upon Le Brun: permanent chancellor of the Academy and director of the Gobelins (1663), Knight of the Order of St. Michael, and supervisor of buildings in 1664.

1683. Colbert dies and his successor, Louvois, removed him from his most important positions, in favor of Mignard.

1690. Charles Le Brun dies in Paris, the most characteristic painter and decorator of the time of the Sun King.

THE RURALISM OF THE LE NAIN BROTHERS

Exploring French painting of the seventeenth century, we would be remiss were we to omit the works painted by the Le Nain brothers, especially the two elder ones, Antoine and Louis. In France, they represented the genre painting that was developed in Holland by Brueghel, Teniers, and van Ostade, specialists in rural themes, especially feast scenes and taverns. The works by the younger of the brothers, Mathieu, was more in line with the portrait painting of the time and is not as interesting as the painting of his elder brothers, who voluntarily stayed away from the themes and fashions of the court.

The Painting of Antoine and Louis Le Nain

They depict peasant life with a realism unique in seventeenth-century French art. The three brothers were born in Laon, a city in the north of France, bordering on the Netherlands, and they had a foreign painter as their teacher. From the Flemish air that pervades much of their work, we might suppose that this foreign master was a painter from Holland. Along with geographical proximity, this explains how pictorial ruralism was introduced into France by Antoine and Louis Le Nain, as a replica of the Dutch tradition.

However, in Le Nain's paintings, the atmosphere that surrounds the figures is devoid of the tavern atmosphere so characteristic of Dutch genre painting. The Le Nain brothers never painted tavern scenes. They were French painters and painted French peasants and artisans who drank no gin but wine from Champagne, in the fields, in the doorways, or inside

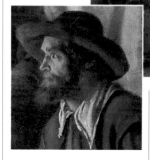

Louis Le Nain. A Blacksmith in His Forge. Oil on canvas, 22 1/4 × 27". Louvre, Paris. The artist seeks realism with a moralizing idealism to exalt the work carried out by the masses in this highly creative painting (see the detail of the head).

their homes. Their figures are humble, sometimes tired men and women, with human dignity

satisfied with their work and that of their family. They do, indeed, have rustic faces, but they are also undoubtedly intelligent. Since the Le Nain brothers were neither peasants nor country folk, the reason they painted these figures was perhaps the curiosity that the nobles and bourgeois felt for these humble characters.

Antoine and, to a greater extent, Louis Le Nain's, painting is authentic, little concerned with fashionable theories about beauty and composition. They aim to capture the truth of simple people and rustic surroundings, expressed in a poetic way thanks to a minute study of light and a sense of composition that eschews anything that might appear artificial.

This painting has a pleasant plasticity and modeling in the chiaroscuro style, with textural

Among Antoine's early religious works are:

The Adoration (Louvre, Paris), which formed part of a series on the life of the Virgin. Among his genre works, *Portraits in an Interior* and *Family Gathering* (Louvre, Paris) and *Card Players* (State Museum, Berlin).
Louis, who worked with his brother on several works, undoubtedly produced among

the most remarkable documents of Baroque naturalism, painted in a most sober fashion and with vague references to Caravaggio and Vouet. *The Cart, Family of Peasants* and especially, *A Blacksmith in His Forge* (in the Louvre), are is most well-known paintings.

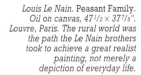

The Academic Tendency. Le Brun **45**
The Ruralism of the Le Nain Brothers
Mignard and Le Lorrain

Louis Le Nain. Peasant Family. Oil on canvas, 47 1/2 × 37 7/8". Louvre, Paris. The rural world was the path the Le Nain brothers took to achieve a great realist painting, not merely a depiction of everyday life.

brushwork. Referring to Louis Le Nain's painting, the French poet and critic Sainte-Beuve (1804–1869) wrote:

"Despite the immobility of the composition (which can only be seen by observing and analyzing), the light effects are so lifelike, abundant, and harmonious that the work seduces us, pleases the eye, and calms the heart."

Mathieu Le Nain, The Last Supper at Emaus (c.1645). Oil on canvas, 35 7/8 × 29 1/4". Louvre, Paris. The paintings of the younger Le Nain reveal a greater conventionalism, a more "fashionable" approach.

When he began to paint, **Mathieu Le Nain** (1608–1677) also did so in this style, but he soon turned to portrait painting, a more lucrative specialty that he completely dedicated himself to with relative fortune and quality.

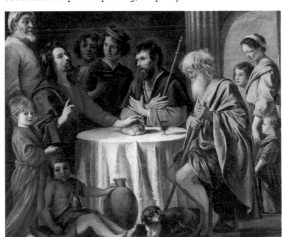

THE ARTISTS' LIFE

1588. Antoine Le Nain is born in Laon.
1593. Louis is born in the same city.
1608. Mathieu is born in Laon. Their father, a government employee, had personal possessions, so it is assumed that the Le Nain were a wealthy family.
1629. This year could be considered the start of their career, when the Le Nains move to Paris and take

up residence in Saint-Germain-des-Prés, an abbey in which there was a group of artists. It would appear they took refuge there to escape the taxes in the city of Paris.
1629. Louis, who trained together with his brother Antoine, travels to Rome, acquiring unforgettable memories.
1630. Again in Paris, Louis Le Nain continues to work

with his elder brother. Antoine and Louis never separated: they lived and worked together always.
1648. Antoine and Louis Le Nain are received into the French Royal Academy of Painting and Sculpture. This recognition comes a little late as they both die the same year, 1648: first Antoine and just two days later, his inseparable brother Louis.

MIGNARD AND LE LORRAIN

Pierre Mignard, the rival and successor of Le Brun, was a genuine representative
of the academic painting of the last decades of the seventeenth century, when a
new taste for gallantry began to appear in the higher circles of French
society as represented in the works of Watteau. Le Lorrain was a
Classicist who used his lyricism in the most imaginative landscape
painting representative of the seventeenth century.

Pierre Mignard, the Roman

When, after Colbert's death, Le Brun was removed from his dominant position in official French art, Mignard represented the culmination of the academic ideal during the latter decades of the reign of Louis XIV.

Mignard's Painting

Mignard's academic Classicism, after his Roman period, came to the full when the Queen Mother, Anne of Austria, commissioned him to decorate the church of Val-de-Grâce (1663). This work, with its academic rigor, is reminiscent of the most characteristic of the "visions" of the great fresco painters of the Italian Baroque. Groups of "worshippers" (the Apostles, the Prophets, the Evangelists, the Saints, the Fathers of the Church) were organized in a concentric composition, whose main line converges on the Holy Trinity

Pierre Mignard. The Virgin of the Grapes (1640–1650). Oil on canvas, $36^5/_8 \times 47^1/_8$". Louvre, Paris. A beautiful example of Mignard's academic rigor applied to a religious theme.

Pierre Mignard. Portrait of Mme de Grignan. Oil on canvas, Carnavalet Museum, Paris. The exquisite flesh tones and pictorial quality of the dress and adornments explain Mignard's success as a portrait painter.

THE ARTIST'S LIFE

1612. Pierre Mignard is born in Troyes. His brother Nicolas (1606–1668), a magnificent portrait painter, is the family precedent to Pierre's academism, who trained in the study of Classical sculpture and the Italian masters of Fontainbleau. He was a disciple of J. Boucher and Simon Vouet.

1635–1657. He works in Rome next to his master. There he took on the arduous task of reproducing all the paintings in the Farnese Gallery, the works of the Carracci brothers, while painting portraits of cardinals, ambassadors, dignitaries, and popes.

1657. Summoned by Louis XIV, he returned to France where he specialized in portraits. With his paintings of the cupola of Val-de-Grâce, he won the praise of the king and the friendship of many high society figures. Louvois, upon Le Brun's death, appointed him professor, governor, director, and chancellor of the Academy. A successor to Le Brun in the eyes of Louis XIV, Mignard was finally able to impose his criteria. The honors only lasted a few years, as he died in 1695, five short years after his rival and predecessor in the Academy.

which, with its divine light, illuminates all the figures.

But what is most admired nowadays of Mignard's work are his portraits. With a steady hand, he captured the psychology of his subjects, dressed up in trivial fashion, so popular at the time: portrait of *Mme de Grignan, Mme de Sévigné, Bossuet, La Bruyère and Louvois, Pope Urban VIII, Innocent X and Alexander VII,* among others.

Claude Gellée, Le Lorrain

French Classicist Landscape Painting in the Seventeenth Century

Apart from the splendid landscapes of Poussin, the most genuine representative of seventeenth-century landscape painting is Claude Gellée, better known as Le Lorrain, who was born in Chamagne, a village in the independent duchy of Lorraine, in 1600. From a very humble family, he was a shepherd until the age of thirteen when he decided to emigrate to Italy as an apprentice pastry-cook. Once there, he trained as a painter under Agostino Tassi, Paul Brill, and Adam Elsheimer.

Le Lorrain's landscapes differ from Dutch realism. They are imaginative, constructed of real elements and a lyrical impulse

Le Lorrain. Country Feast *(1639). Oil on canvas, 52⁵/₈ × 40¹/₈".
Louvre, Paris. A gathering of peasants near a city prompts
Le Lorrain to create an imaginary landscape.*

expressed in delicate tonalities that create a Classicist nature of undoubted originality; the foregrounds contrast with dark skies or the light at dawn. Between the foreground and the horizon, the observer notices buildings, groves, figures standing or strolling, some standing out against the light and others absorbed by the shadows.

His numerous sketches drawn from nature on the outskirts of Rome, Naples, Capri, or Genoa with the inclusion of elements belonging to antiquity, are not exact renditions of reality but

rather a literary reinterpretation fueled by Claude's constant reading of Ovid, Horace, and Virgil.

At the height of his career (1639–1660), Le Lorrain's landscapes offered broad horizons, linear perspective, and a sensation of depth obtained by his unrivaled technique for creating the atmosphere of inaccessible distance, with perfect color gradations from the foreground to the background that anticipate Romantic landscape painting. *Country Feast* (1639) and *Seaport* (1639), both in the Louvre, and above all *Landscape with the Temple of Delphos* (1650) in the Doria Pamphili Gallery, Rome are some of Le Lorrain's most representative landscape works.

And Then . . .

With Le Brun and Mignard, the Great Century of France came to a close. French painting was later to abandon Classicism and take on more Baroque characteristics, especially in those genres that most lend themselves to grandiloquence: historical, religious, and mythological. Coypel (1661–1722), Largillière (1656–1746), and Rigaud (1659–1743) are representative of the late seventeenth-century French Baroque.

Le Lorrain. Seaport: The Embarkation of Saint Ursula. *Oil on canvas. National Gallery, London. The architecture of Classicist inspiration is the artist's solution for the historical moment in which he lives.*

WATTEAU AND FRAGONARD

During the last years of the seventeenth century and the first years of the eighteenth, a new genre introduced by Claude Gillot (1673–1722) appeared in French painting. Gallant festivities, offering new poetic and carefree aesthetics completely removed from the Classicism of the Academy, portray a vivid reflection of the period: the Rococo. Its society, colorful and theatrical, given to pleasure and the easy life, introduced a painting of brilliant colors, sensual forms. The most representative figures of this style were, without doubt, Watteau and Fragonard.

Jean-Antoine Watteau

The Different Painting of Watteau. Influences.

The tremendous impetus of Watteau's painting did not stem from the Academy, nor from Italy (tuberculosis prevented him from going), but from very different sources.

It is to the influence of Claude Gillot that Watteau owed his enormous interest for the Italian comedy and the gallant festivity, subjects that he took to the highest levels of refinement and poetic depth. It was thanks to Claude Audran, the curator of the Medici Gallery in the Luxembourg Palace, that Watteau knew Rubens, whose mastery of chromatics exerted a lasting mark on his palette. The theater and Ruben's chromatism fascinated Watteau. *Gilles, The Embarkation for Cythera, The Indifferent, The Country Concert,* all in the Louvre, Paris; *Feast in the Park* (The Prado, Madrid) *Mezzetin* (Metropolitan Museum, New York), *The Charms of Life* (Wallace Collection, London), *L'Enseigne de Gersaint* (Staatliche Museum, Berlin), *The Concert* (Charlottenburg Castle, Berlin), together with his extraordinary drawings bear witness to the poetic and melancholic art of one of the greatest French painters and draftsmen.

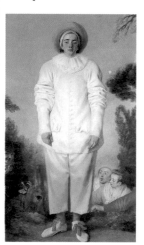

Watteau. The Embarkation for Cythera (1717), Oil on canvas, 76⁷/₈ × 50". Louvre, Paris. One of his most famous paintings, it is an elegy to youth and love and the best example of his refined technique.

Watteau. Gilles (Pierrot). 1717–1719. Oil on canvas, 58 × 71³/₄". Louvre, Paris.

THE ARTIST'S LIFE

1684. Jean-Antoine Watteau was born in Valenciennes. He showed an enormous talent for drawing from an early age.

1702. He is in Paris, working with Albert Gerin, a specialist in religious themes.

1705. He meets Claude Gillot and Claude Audran, to whom he owes his definitive style and fondness for landscapes.

1709. He enters the competition for the Prix de Rome and obtains second place.

1712. He is admitted into the French Royal Academy as assistant.

1717. With the presentation of his elegy to youth and love, *The Embarkation for Cythera,* he is accepted into the Academy as a full member.

1719. He travels to London to consult a famous physician about his health. On his return, he lives for a while with an art dealer, Gersaint, for whom he paints one of his most admirable works: *L'Enseigne de Gersaint.*

1721. He dies of tuberculosis in Nogent-sur-Marne, at Gersaint's home, at the age of thirty-seven.

Jean-Honoré Fragonard

Fragonard's Painting

The painting of the last, great Rococo painter is mostly a genuine representation of the pleasurable aspects of life, in compositions with a theatrical air and excellent portraits.

Love, the landscape, and intimacy presented as a gallant game acquire, thanks to the artist's solid training, creative values that are far removed from frivolity. Good examples of the genre are *The Appointment* and *The Crowned Lover* (Frick Collection, New York),

and *The Stolen Kiss* (Hermitage Museum).

Jean-Honoré Fragonard's technique used much texture, with a creamy consistency that, together with his speed, spontaneity, and light brushwork, associate him with Impressionism.

THE ARTIST'S LIFE

1732. He is born in Grasse, a city in Provence.

1751. He is disciple to Chardin and Boucher, from whom he receives an excellent theoretical and practical training. Through Boucher he gains his independence from his first master.

1752. Having been entered by his master, he wins the Prix de Rome.

1756. After completing his studies in the Academy,

he travels to Italy, where he paints religious works and portraits.

1761. On his return to France, he exhibits a few landscapes and is accepted by the Academy.

1767. He stops exhibiting at the Salon and concentrates in painting works related to Classical French tragedy, gallant themes, and what has been called libertine painting (*The Swing*, Wallace Collection, London

and *The Doughnut*, private collection, Paris), disdaining those genres that were no longer fashionable. Although the National Assembly appointed him curator in the Louvre, he died forgotten and his works were auctioned off at ridiculous prices. This was the year 1805, the height of Neoclassicism.

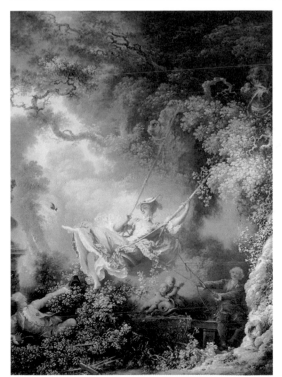

Fragonard. The Swing. *(1767). Oil on canvas, 25 × 31 ⁵/₈". Wallace Collection, London. Of the so-called "canaille" paintings by Fragonard, this is considered the masterpiece of expression of the pleasures of life.*

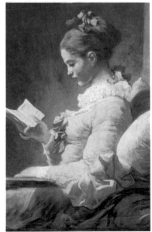

Fragonard. A Young Girl Reading. *Oil on canvas. National Gallery of Art, Washington, D.C. An example of how Fragonard's painting can reach the most genuine intimacy in outstanding portraits.*

BOUCHER, CHARDIN, AND QUENTIN DE LA TOUR

Before leaving the eighteenth-century French Baroque, other artists must be mentioned who, like Boucher, Chardin, and Quentin de La Tour, filled the transition period between Watteau and Fragonard with a sensualist painting that could be considered as midway between the two most classically French of styles: those of Poussin and David.

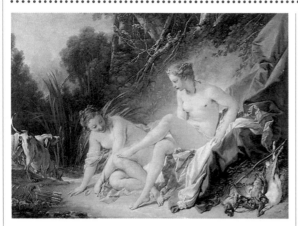

François Boucher. Bath of Diana (1742).
Oil on canvas, 28¹/₂ × 21⁷/₈". Louvre, Paris.

François Boucher

Boucher the Painter

Because he occupied the "interregnum" between Watteau and Fragonard, François Boucher (1703–1770) has been virtually ignored by art historians, though he best represented French artistic tastes when he abandoned all delusions of grandeur and moved toward a painting of sensual grace, with an intimate air, concentrating on saucy detail and irony. Boucher employed a range of colors which, in addition to sculptural forms, brought out material qualities, those which reach the senses most directly. Boucher was not an academic painter, despite having received the highest award of the Academy in 1723 and having been admitted to it in 1734.

After dedicating himself to illustrating editions of Molière's and La Fontaine's works, he devoted himself entirely to mythological painting. His painting *Reinhold and Armilda* (1734, Louvre, Paris)

opened the doors of the Academy to him, although *Bath of Diana* (1742, Louvre, Paris) was his most representative mythological work.

As head decorator of the Royal Academy of Music (1744–1748), he painted backdrops and

scenery with delightful bucolic atmosphere. In 1765, after the death of van Loo, he was named director of the Gobelins Tapestry Factory and First Painter to King Louis XV. With the emergence of Neoclassicism, Boucher began to lose his preeminence. The marginalization of his works drove him to his death. One of Boucher's merits was that he never gave in to the demands of the Academy. Other young artists followed his example and lived without official support, solely from the demand existing outside of academic circles.

Chardin

Jean-Baptiste Siméon Chardin the Painter

As a painter of everyday objects, Chardin occupies a special place in French eighteenth-century art. Born in Paris in 1699 to a family of cabinetmakers, he was one of the most important still-life

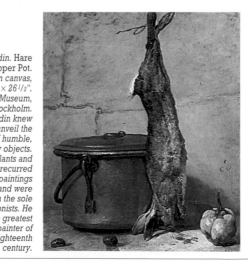

Chardin. Hare with Copper Pot. Oil on canvas, 22¹/₄ × 26¹/₂". National Museum, Stockholm. Chardin knew how to unveil the beauty of humble, everyday objects. Dead plants and animals recurred in his paintings and were often the sole protagonists. He was the greatest still-life painter of the eighteenth century.

painters in history, perhaps thanks to his studies of Flemish and Dutch painting.

Although most of his paintings were still lifes, Chardin also carried out, in collaboration with van Loo, decoration and restoration work at Fontainebleau, as well as some portraits—such as *Young Artist Sharpening a Pencil* (1733, Louvre, Paris)—and genre paintings—*The Supplier* (1739, Louvre, Paris), for example—of very high quality. Along with Quentin de La Tour, he was one of the greatest pastel artists of France, the author of such works as *Self-Portrait with Green Visor* (1739, Louvre, Paris).

Against the brilliance of silks and moirés, Chardin opposed the thematic frivolity of the painting of his time, the profound humanity of the common people and, above all, the recreation of everyday objects, from whose apparent insignificance he extracted a serene beauty.

Chardin. Self-Portrait with Spectacles (1771). Pastel on paper, Cabinet des Dessins, Louvre, Paris.

Maurice-Quentin de La Tour

The Greatest French Pastel Artist

The pastel painting divulged by Rosalba Carriera and practiced by Chardin reached its maximum quality and popularity with the undisputable master of the technique, Maurice-Quentin de La Tour (1704–1788).

Without doubt, he was the greatest French pastel portrait artist, a skill that allowed him to

Quentin de La Tour. Portrait of Mme Pompadour. Pastel on paper, Cabinet des Dessins, Louvre, Paris. A magnificent example of the purest de La Tour style. He was capable of achieving truly painterly qualities using the pastel technique, which, though Carriera had elevated it to a high artistic level, was nonetheless considered a procedure closer to that of drawing than painting.

make himself a place, which he occupied with brilliance, among the high society of the Louis XV era.

The frivolous aristocracy that requested his services was taken by the unique qualities of his painting, at once soft and brilliant, which could only be achieved through the pastel technique as executed by a true virtuoso.

When de La Tour settled in Paris (1727), he had already studied painting in Cambrai and Reims. Nevertheless, he took it upon himself to study for ten more years, after which, considering himself sufficiently prepared, he presented himself to the public. The pastel portraits by de La Tour created such a wave of enthusiasm, first among intellectuals and then among the aristocracy, that absolutely everyone wanted to have a portrait by him.

In his extensive portraiture, many works are in reality sketches of spontaneous directness. These were deliberately unfinished

pieces, a characteristic that was gaining popularity in the society of the time. Nevertheless, this great pastel artist did not stop producing perfectly finished works as well, prodigies of technical mastery such as his *Self-Portrait* of 1751 (Musée de Picardie, Amiens) and the *Portrait of Mme de Pompadour* of 1755 (Louvre, Paris). These pieces lose all reminiscence of drawing to acquire the full status of artwork of such high "social" category as oil paintings.

De La Tour promoted his popularity by donning a mask of disdain and superiority (his self-portrait is quite provoking), which seems to have delighted his clientele, though he showed himself to be a generous protector of students and poor people.

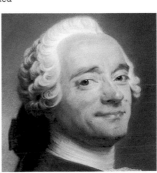

Quentin de La Tour. Self-Portrait (detail), 1751. Pastel on canvas, $15^{1}/_{4} \times 12^{1}/_{8}$". Musée de Picardie, Amiens, France.

SEVENTEENTH-CENTURY REALISM (I). ZURBARÁN

With the death of El Greco in 1614, the most original of European Mannerists disappeared and Mannerism gave way to Realism in Spain. Luis Tristán (1576–1624), disciple of El Greco in Toledo, and Francisco Pacheco (1564–1654) in Seville, among others, paved the way toward the new concepts underlying Realism. Another Sevillan, Francisco Herrera the Elder (1576–1656), as well as the Valencian Francisco Ribalta (1564–1628), took the definitive step towards pictorial Realism in Spain.

The Artwork of Francisco de Zurbarán y Márquez

Along with Velázquez and Ribera, he constitutes one of the pillars of Spanish Realism. Zurbarán's painting is original, even advanced compared with the Baroque style predominant in his time. His style demonstrates a great independence from his contemporaries. His love of simplicity and authenticity led him to create an atmosphere all his own, unmistakable yet undefinable, present in both his

Zurbarán. Saint Casilda (circa 1640). Oil on canvas, 38 1/4 × 71 3/4". The Prado, Madrid.

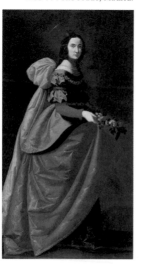

Zurbarán. Still Life (1633–1640). Oil on canvas, 32 3/4 × 18". The Prado, Madrid. This painting shows Zurbarán's search for beauty in simple objects.

THE ARTIST'S LIFE

1598. Francisco de Zurbarán y Márquez is born in Fuente de Cantos, in Spain. His father, of Basque origin, was the well-off owner of a notions store.

1614. He moves to Seville to study and work with Pedro Díaz de Villanueva. His apprenticeship lasts three years.

1617. After returning to Extremadura, he marries for the first time in Llerena to María Páez Jiménez. She bears a son, Juan, who is to become his father's assistant, and two daughters, María and Paula Isabel.

1625. After the death of his first wife in 1623, he marries for a second time, this time with Beatriz de Morales. They have a daughter, Jerónima.

1629. He works for the Dominicans of Seville as well as the Mercedarians, with whom he decides to live in order to produce twenty-two paintings on the life of Saint Peter Nolasco. The Sevillan Cathedral Chapter invites Zurbarán to establish himself permanently in the city. He moves with his family and collaborators into the house at Callejón del Alcázar, number 27.

1633. Zurbarán travels to Madrid, probably on Velázquez's invitation, where he paints for Philip IV.

1637–1639. He devotes himself entirely to painting the altarpiece and side chapel of the Carthusian Monastery in Jerez and the sacristy of the Jerónimos of Guadalupe. Zurbarán reaches artistic maturity.

1639. His wife Beatriz de Morales dies. The painter finds refuge at the Mercedarian Monastery of San José.

1644. He marries a young widow, Leonor de Torderas, with whom he has a daughter, Micaela.

1658. A series of hardships (among others, the consequences of the bubonic plague that had overrun Seville in 1649) lead Zurbarán to settle in Madrid.

1664. He dies on August 27. The last years of his life are fraught with mishaps.

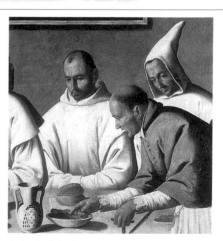

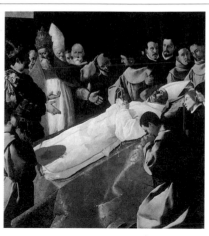

Zurbarán. Saint Hugo Visiting the Refectory *(detail), 1633. Oil on canvas, 119³/₄ × 102¹/₈". Museo de Bellas Artes, Seville, Spain. This detail of one of his best works gives an idea of the whites that Zurbarán knew how to see and "extract" from the Carthusian monks' habits, to which he lent an extraordinary, almost supernatural material quality.*

Zurbarán. Exposition of the Reclining Body of Saint Bonaventura *(circa 1629). Oil on canvas, 85³/₄ × 95¹/₂". The Prado, Madrid. One of his most elaborate paintings, with very finely worked composition, coloring, and representation on canvas of the textures and material qualities of the monks' various habits, clothing, and hierarchical attributes.*

marvelous still lifes and his portraits of monks. Zurbarán painted religious communities, chronicling, in fact, the lives of monks, whom he painted with unequalled authenticity, portraying their physical as well as spiritual features. The habits of thick white cloth acquire sculptural dimensions. "Zurbarán whites" are unique in the history of art. His painting, of a material quality obtained through an impasto of uniform thickness, places him in the so-called second generation of tenebrists, whose treatment of chiaroscuro eliminates extreme contrasts. Zurbarán's typical treatment of light in each painted element lends nearly mystical qualities to humble everyday objects. This is achieved through a combination of perfect execution and simple composition.

It has been said of Zurbarán's painting that it converts the human world into something sacred and brings the supernatural down to earth. In a sense, this original idea lies behind what could be called his "religious portraiture," which attributes religious characteristics to the realistic representation of ladies of high society of the time.

Zurbarán was very prolific, with a production ranging from works executed entirely by him to studio pieces for which the actual master's participation varied. The following is a list of his most representative works:

Saint Serapis (1628), Wadsworth Atheneum, Hartford, Connecticut. This work is the most impressive testimony of his first period in Seville.
The Vision of Saint Peter Nolasco (1629), The Prado, Madrid. This formed part of his series for the Mercedarian Order of Seville, as did the previous painting.
Series of Paintings on Saint Buenaventura (1629). The most notable examples are in the Louvre, Paris and the State Museum, Berlin.
The Birth of the Virgin (1629), Norton Simon Museum, Pasadena, California. A work of great luminosity.
The Immaculate Virgin of Jadraque (circa 1630), Diocesian Museum of Sigüenza, Guadalajarra, Spain. With this painting, Zurbarán initiates a series on this subject.
Christ Crucified (1630). A series of which the two pieces in the Cathedral of Seville, Spain are the best examples.

The Labors of Hercules (1634), The Prado, Madrid. Originally created for the Salón de Reinos of the Buen Retiro Palace in Madrid.
The Virgin of the Carthusians (1630–1635), painted for the Carthusian Monastery at Jerez. Museo de Bellas Artes, Seville, Spain.
Sacristy Paintings for the Hieronymite Monastery at Guadalupe (1638–1639), Cáceres, Spain.
Still Lifes. These are some of his most remarkable creations, some of which are to be found in the Prado, the Norton Simon Museum in Pasadena and the Museum of Modern Art in Barcelona, Spain.
Saint Margaret (1640), National Gallery, London, and other saints painted as ladies of high society.
Portraits: He painted portraits throughout his entire career, the most notable of which were created during his last period as a painter. An exemplary piece is *Portrait of Brother Diego of Deza* (The Prado, Madrid).

SEVENTEENTH-CENTURY REALISM (II). ALONSO CANO AND VALDÉS LEAL

Andalusia, either by birth or adoption (as in the case of Zurbarán), was home to many of the painters who brought the new Spanish values to the capital, when some of them settled there, as well as to all the other centers of importance in Spain. Along with Zurbarán and Murillo, Alonso Cano and Valdés Leal were the most representative painters of seventeenth-century Spanish Baroque of Andalusian origin.

Alonso Cano

Characteristics of His Work

Alonso Cano's artistic work reveals more of an involvement with Renaissance ideals than Baroque concerns, though his life, fraught with adventures and conflicts, was full of the Baroque excesses that do not appear in his paintings. The stylistic characteristics of his work show the influence received in the cities where he worked as a consequence of his turbulent life: Seville, Madrid, and Granada.

During his first period in Seville, he painted along the lines of Velázquez's work of

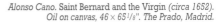

Alonso Cano. The Dead Christ Supported by an Angel (circa 1646). Oil on canvas, 47¹/₈ × 30³/₈". The Prado, Madrid.

the same period, with obvious tenebrist influences from Pacheco and Zurbarán.

His Madrid period, alongside Velázquez and near the royal collections, brought about considerable changes in his painting: Italian influence and the assimilation of Velázquez's technique are evident in his best pieces. His paintings from the years spent in Granada, where he worked mainly as a sculptor after leaving Madrid, reveal a certain Flemish influence.

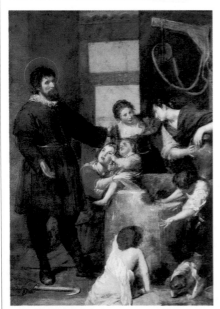

Alonso Cano. St. Isidore's Miracle of the Well (1648). Oil on canvas, 58¹/₈ × 84¹/₄". The Prado, Madrid.

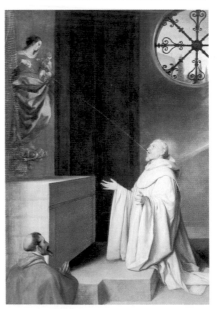

Alonso Cano. Saint Bernard and the Virgin (circa 1652). Oil on canvas, 46 × 65¹/₈". The Prado, Madrid.

THE ARTIST'S LIFE AND WORKS

1601. Alonso Cano is born in Granada. Some years later, still a child, he is accepted into the Sevillan studios of Juan del Castillo, Pacheco and Herrera the Elder.

1628. He paints the *Altar of Saint Theresa* in the San Alberto Church of Seville. In this first period, he also paints *Saint John Evangelist Assisted by an Angel* (Wallace Collection, London), a *Virgin with Child* series (Cathedral of Seville), *Portrait of a Clergyman* (Hispanic Society, New York), and *Saint John Evangelist* (Santa Paula Convent, Seville).

1636. His father dies. He paints the *Central Altarpiece of the Lebrija Church.*

1637. His violent character leads him to a duel with another Sevillan painter, Llanos Valdés, who comes out of it

with a crippled hand. Cano flees to Madrid.

1643. Around this time he directs the construction work in the Cathedral of Toledo and becomes famous for his decoration of the Gates of Gualajara in Madrid in preparation for the entrance of the Mariana of Austria.

1644. His notoricty as a violent person brings him more problems when his second wife is stabbed to death, and the court declares him suspect. He leaves Madrid and goes into hiding in Valencia, though only for a short period.

1646. Having returned to Madrid, he begins his most brilliant period with works such as *Saint John* (Museum of Málaga), *Saint Jerome* (The Prado), *Pietà,* based on an engraving by van Dyck and *Jesus and the Samaritan*

(Academia de San Fernando, Madrid), *Virgin with Child* (The Prado). Two remarkable works, *Christ in Limbo* (1646–1650, Los Angeles County Museum of Art, California), done in an Italianate style, and *St. Isidore's Miracle of the Well* (1648), of clear Velázquez influence, are considered his masterpieces.

1652. He settles in Granada, where he paints *The Holy Family, Death of Saint Francis* (Academia de San Fernando, Madrid), and *Vision of Saint Bernard* (The Prado, Madrid). Four years later, he is ordained as subdeacon.

1667. He dies in Granada, after having directed the construction of the cathedral façade as an architect.

Juan de Valdés Leal

Characteristics of His Work

Juan de Valdés Leal, who was born and died in Seville (1622–1690), contributed dynamism and passion that other Sevillan masters of the Spanish Baroque failed to achieve. His paintings, in various styles, responded to changing influences.

He was not a precocious artist, but his first painting, Saint Andrew (San Francisco Church in Córdoba), dated 1645, already revealed a clear maturity.

In *The Virgin of the Silversmiths with Saint Eloy and Saint Anthony of Padua* (1554, Museo Provincial de Bellas Artes, Córdoba, Spain), he defined his iconographic model of the Virgin.

In 1656, he executed a series of paintings for the Santa Clara Church in Carmona (Museo de Bellas Artes, Seville, and Fundación March, Madrid). *The Profession of Saint Claire* and *Death of Saint Claire* reveal the influence of Herrera the Elder.

Toward 1656 the painter entered a period of greater Baroque exaltation evident in

Betrothal of Saint Catherine (Museo de Bellas Artes, Seville) as well as in his series of *Immaculates* and his series the *Life of Saint Jerome* for the San Jerónimo Convent in Buenavista (today in the Museo de Bellas Artes, Seville). The altarpiece *Carmen Convent* (Córdoba, 1658), dedicated to Saint Elijah, reveals the painter's frequent stylistic changes. Among the paintings belonging to the altarpiece are *Dream of the Prophet* with the influence of El

Greco, and *Carmen Virgin* inspired by Zurbarán.

Saint John and the Three Maries in Search of Jesus (Museo de Bellas Artes, Seville) and *Donning of the Chasuble* (The Prado), both from 1660, are also important works.

In 1672, he painted his two most singular pieces, representative of the sense of tragedy of the 17th-century "España negra" (Black Spain): *Finis Gloriae Mundi* (Neither More Nor Less), and *Triumph of Death* (In Ictu Oculi) (Museo de Bellas Artes, Seville).

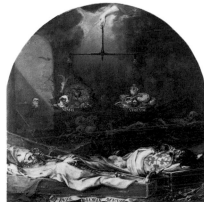

Valdés Leal.
Finis Gloriae
Mundi (circa
1672). Oil on
panel, 84$^{1}/_{4}$ ×
85$^{3}/_{4}$". Museo
de Bellas Artes,
Seville. One
of the most
representative
works of Spanish
"pintura negra"
(Black Painting),
overflowing with
a Baroque sense
of pathos.

SEVENTEENTH CENTURY REALISM (III). BARTOLOMÉ ESTEBAN MURILLO

Though his extensive work has received both praise and criticism over the years, it is impossible to deny Bartolomé Esteban Murillo two great attributes. He was the most technically genuine of the seventeenth-century Andalusian Realists, and in human and thematic terms, he was able to represent Sevillan populism, both religious and profane, as no one else had done before.

Murillo's Painting

Murillo's first period was marked by tenebrist tendencies, namely Sevillan tenebrism. His work included religious as well as genre and populist paintings.

Toward 1650, beginning with his *Immaculate Conception*, Murillo's painting changed its orientation. All traces of Sevillan tenebrism disappeared to give way to a more direct style produced by rich colorist brushstrokes with loose, direct touches and light colors. This pictorial "modernism" distinguished Murillo's aesthetic.

In the last ten years of his life, Murillo's painting regained a tenebrist tendency, especially in his religious paintings. As a portrait artist, Murillo practiced a sober Realism, in accordance with the austerity of his models.

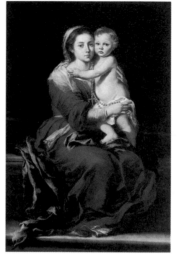

Murillo. The Virgin of the Rosary. Oil on canvas, 42⁷/₈ × 66". The Prado, Madrid. Retaining a certain tenebrist air, this represent-ation of Mary is one of the loveliest and pictorially most noteworthy of all "Virgin with Child" paintings, including those of Raphael. Murillo knew how to satisfy popular taste without sacrificing artistic values.

Murillo. Children Playing with Dice *(1665–1667). Oil on canvas, 42¹/₄ × 57". Alte Pinakothek, Munich.*

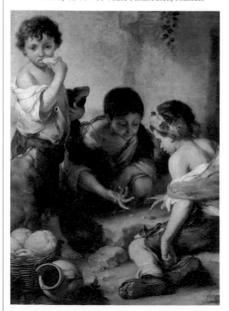

Murillo. The Immaculate Conception *(circa 1678). Oil on canvas, 74 × 106⁷/₈". The Prado, Madrid.*

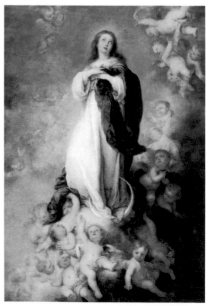

Critics have contemptuously said that Murillo was simply a painter of children and angels. His paintings of the Baby Jesus or Saint John, for example, are portrayals of an "overdone" piety. But Murillo's work shows the genius of one of the greatest painters of the Baroque. Bartolomé Esteban Murillo lived for his painting, working intensely. Despite his recognition throughout Europe, his ambitions as a painter never succeeded in separating him from his native Seville. He even refused Charles II's invitation to go and live in

Murillo. Patrician John and His Wife Reveal His Dream to Pope Liberius (circa 1662–1665). Oil on canvas, 203¹/₂ × 90¹/₂". The Prado, Madrid.

Madrid. We can say that Murillo's life was his painting—they were intrinsic to one another and evolved together.

THE ARTIST'S LIFE AND WORKS

1617. Bartolomé Esteban Murillo is born and orphaned at a young age. He enters the studio of Juan del Castillo, a specialist in *Immaculate Conception*.

1645–1646. He produces his first eleven works originally for the small cloister of San Francisco in Seville, scattered today in various museums. Falling within the Sevillan tenebrist vein of Zurbarán are *Saint Francis* and *The Angels' Kitchen* (Louvre, Paris), *Saint Domingo of Alcalá Giving Food to the Poor* and *Saint Francis Comforted by an Angel* (Academia de San Fernando, Madrid).

1650. Murillo begins to paint his most original works along more popular lines: genre scenes with children or women. To the first series belong: *Children Eating Melon and Grapes*, *Children Playing with Dice*, and *Children Delousing Each Other* (Pinakothek, Munich) They are street children, little rascals who, far from any sort of misery, reflect their joy of life as well as their humbleness. Some of his best-known genre scenes with women are *Grandmother Delousing Her Grandson* (Pinakothek, Munich), *Old Woman Spinning* and *Two Women at a Window* (National Gallery of Art, Washington).

1650. He paints his *Immaculate Conception*, "The Great" (137⁷/₈ × 170") for the San Francisco Church, today in the Museo de Bellas Artes of Seville. With this work he sets an iconographic model that has become part of the Marian painting tradition. It marks the turning point between his tenebrist period and his new painting style.

1656. The evolution begun with the *Immaculate* takes on a definitive character in works like *Saint Isidor*, *Saint Leander*, and *Saint Anthony of Padua* in the Cathedral of Seville. The new Murillo gives his paintings a diaphanous air, as if shrouding them in a light haze of enchantment.

1656–1665. During these years, Murillo produces his masterpieces, four semicircular paintings commissioned by the priest Justino Nave y Yébenes for the Nuestra Señora la Blanca Church. *Patrician John's Dream* and *The Married Couple's Visit to the Pope* are displayed in the Prado, Madrid, whereas the other two—*The Virgin with Two Priests and Two Cherubim* and *Faith Adored by a Mother, Her Son and Four Monks*—belong to a private collection in Britain.

1670. At approximately this time, Murillo rejects King Charles II's offer to work in Madrid.

1672. Murillo gets paid for his *Saint Isabel of Hungary Curing Lepers* (The Prado, Madrid), which was part of a series of eight paintings for the Hospital de Miguel Mañara stolen by French Marshal Soult and today dispersed throughout various museums.

1676. Brother Francisco de Jerez commissions Murillo to decorate the church of the Capuchin Convent in Cádiz, including painting the central altarpiece and those of the side chapels. In less than two years, Murillo paints twenty-two large canvases that can be seen at the Museum of Fine Arts in Seville and in several other collections. This tremendous undertaking demonstrates the artist's capacity for prolific creativity.

1678. He paints the *Central Altarpiece of the St. Agustine Church* and the *Saint Thomas of Villanueva Altarpiece*. The works originally composing these altarpieces, like so many of Murillo's artwork, are dispersed throughout various museums.

1682. On April 3, he dies in Seville after falling off a scaffolding while painting a large canvas for the Capuchin Convent of Cádiz.

SEVENTEENTH-CENTURY REALISM (IV). VELÁZQUEZ

Political and social circumstances, mainly the power of the large monastic orders, caused the Spanish Baroque art of the seventeenth century to differ from the contemporary Baroque art produced throughout the rest of Europe. Over and above this difference, it can also be said that the brush of a single person in Spain created the most unique of all seventeenth-century painting, that of Diego Rodríguez de Silva y Velázquez, doubtless one of the greatest painters of all times.

Velázquez's Work

The above statement about Velázquez can be corroborated by a simple examination of his works, which also serve to chronicle his rather uneventful life. His painting is far removed from philosophical concerns, foreign to formal idealization, and does not seek to reflect deep emotions. In fact, Velázquez's painting reflects an extremely objective point of view. As the popular saying goes, his figures *are what they are and appear as they appear*, impassive for century upon century with the resignation of those who accept themselves, molded by the mundane existence of humanity.

Few dedicatory statements fit the person as well as the one on Seville's monument to Velázquez: *To the painter of Truth*. It was a truth taken in by extraordinarily sensitive eyes and put onto canvas with an authentically genial pictorial expertise and a mastery of tech-

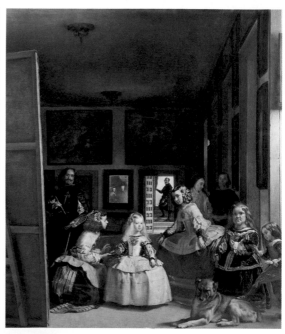

Velázquez. Las Meninas (The Maids of Honor, 1656). Oil on canvas, $121 \times 107^{5}/_{8}$". The Prado, Madrid. One of the most deservedly famous paintings in the world.

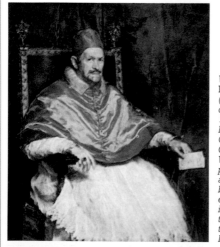

Velázquez. Pope Innocence X (1648). Oil on canvas, $46^{3}/_{4} \times 54^{5}/_{8}$". Doria-Pamphili Gallery, Rome. Considered Velázquez's best portrait, as well as one of the best portraits ever painted, it anticipates the essence of today's "Post-Impressionism."

nique that liberated the painter of the need so keenly felt by many good artists to seek effects and artifice.

The simplicity of his paintings made Velázquez an unequaled portraitist of sober palette, capable of capturing the soul of his models, whom he dignified on canvas, whether they were court buffoons or famous figures.

Velázquez caressed the canvas with the brush when he painted. His brushstrokes achieved a synthesized and technically perfect result, leaving even today's experts at a loss for an explanation.

Velázquez. The Boy from Vallecas (1644). Oil on canvas, 32³/₈ × 41³/₄". The Prado, Madrid.

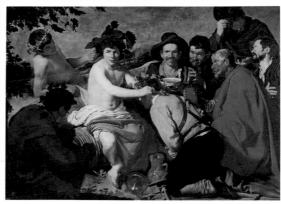

Velázquez. The Triumph of Bacchus (The Drunkards), circa 1627–1628. Oil on canvas, 73³/₈ × 64³/₈". The Prado, Madrid. Popular figures to liven up a mythological god.

THE ARTIST'S LIFE AND WORK

1599. Diego Rodríguez de Silva y Velázquez is born in Seville, where he receives a good education in Latin and the humanities and, from an early age, shows that he is a natural-born painter.

1610. He enters the studio of Francisco Pacheco as an apprentice and passes the painters' guild examination in Seville in 1617. A year later, he marries Juana Pacheco, the daughter of his master Francisco.

1618–1620. He paints the most representative works of his first tenebrist Realist period: *Old Woman Frying Eggs* (National Gallery of Scotland, Edinburgh) and *The Water Seller of Seville* (Wellington Museum, London).

1622. Velázquez visits Madrid to see the palace of El Escorial. During this trip, he paints one of his most sober portraits—*Luis de Góngora* (Museum of Fine Arts, Boston). His wish to paint the kings is frustrated, but through the experienced help of the Don Juan de Fonseca, of whom Velázquez had painted a portrait, the Count-Duke of Olivares allows his definitive entrance to the court.

1626. The artist has now moved to Madrid, and his painting undergoes definitive changes in color and spatial aspects. In this period he realizes his first court portraits, done in a peaceful Realism. He also executes *The Triumph of Bacchus*, better known as *The Drunkards* (The Prado, Madrid), in which the mythological subject matter is carried out in Realist and popular tones.

1629. He travels for the first time to Italy, where he studies the great masters of the Renaissance without ever following them. He produces his famous *Vulcan's Forge* (The Prado, Madrid), a subject matter that served as a pretext to study the nude, light, and atmosphere.

1632–1648. Back in Madrid, Velázquez's realism of austere palette appears in his royal portraits of *Philip IV on Horseback* and *Prince Balthasar Charles* (both from 1636), as well as of dwarves and buffoons, among others *The Buffoon Calabacillas* (1639) and *The Dwarf Francisco Lezcano* (1644). In his official painting, perfectly represented by *The Surrender of Breda* (or *The Spears*, The Prado, Madrid) he leans toward lighter tones.

1648. He takes a second trip to Italy, sent by Philip IV to acquire works of art for the royal collections. He paints *Pope Innocence X*, one of the greatest portraits ever painted.

1650. He carries out another of his masterpieces: *Venus at the Mirror* (National Gallery, London). It is the only female nude he ever painted.

1652–1660. After being named Court Secretary, he paints his last royal portraits in 1655: *Mariana of Austria* and the bust of *Philip IV*. Velázquez reaches the pinnacle of his career, having completely mastered colors and definition of space. *Las Meninas*, or *The Maids of Honor* (1656) and *The Spinners* (1657), both at The Prado in Madrid, are considered to be among the best paintings in the world.

1660. On August 6, the great artist dies, a year after having been bestowed the Order of Knight of Santiago. There has been speculation on the possibility that the king himself may have added the red cross (symbol of the order) that Velázquez is wearing in his self-portrait within the *Meninas* painting.

SEVENTEENTH-CENTURY REALISM (V). THE VALENCIAN JOSÉ DE RIBERA

We have so far seen Seville and Madrid as centers of great seventeenth-century Spanish painting. A third center was the city of Valencia, whose protagonist was Francisco Ribalta (1564–1628). Ribalta was a magnificent painter who, leaving behind the Mannerism of Juan de Juanes (1523–1579), progressively approached Caravaggio's Realism. He created a notable work that marked the way for José de Ribera, known in Italy as Lo Spagnoletto and whom some consider to be a disciple of Ribalta.

The Painting of José de Ribera

Ribera's work was heir, on the one hand, to the mastery of the great Cinquecento artists and the chiaroscuro of Caravaggio. On the other hand, Ribera took up the force and religious themes of Spanish Realism, with its clear charge of mysticism and somewhat morbid dramatism evident in the details of his "martyrdom" paintings, as well as in his works portraying beggars and abnormal people along the lines of Velázquez.

From around 1636 onward, Ribera's painting abandoned the sharp contrasts typical of Caravaggio and evolved toward a more personal solution, adapting a less rigid style and lighter tonality, which occasionally revealed the influence of Guido Reni.

Nonetheless, Ribera attained a perfect combination of Italian and Spanish styles.

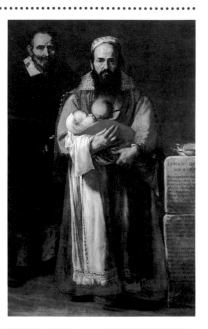

Ribera. Portrait of Magdalena Ventura (The Bearded Woman), 1631. Oil on canvas, 49¹/₂ × 76¹/₂". Hospital de Tavera, Toledo, Spain. A commissioned painting, whose model Ribera combined with his own propensity for the morbid to make it one of the most pathetic of Baroque Realism.

THE ARTIST´S LIFE

1591. José de Ribera is born in Jàtiva, Spain. There is no specific information available about his initial studies. It is probable that he studied under Ribalta.

1610. He moves to Italy, where he lives the rest of his artistic life, though he continues to be a very Spanish painter who strongly influences art in his country.

1610–1616. During his years in Rome, his artistic personality is formed within the naturalist tendencies

of Caravaggio. Despite his bohemian lifestyle, he becomes recognized as one of the best young painters of the time.

1616. Ribera moves to Naples, where he works for the successive Spanish viceroys governing the region. He becomes the leader of his own pictorial school. With him, the School of Naples experiences its age of greatest splendor. In fact, it is in this city that Ribera executes the great majority of his works.

1648. According to contemporaneous accounts, this is the saddest year of Ribera's life. It is said that John Joseph of Austria, illegitimate son of Philip IV who had arrived in Naples a year earlier, seduces and abducts the painter's daughter. Abandoned by John Joseph in Palermo, she enters the Descalzas Convent in Madrid.

1652. Ribera dies in Posilipo, near Naples.

A large amount of Ribera's work from his first Neapolitan period, closely identified with a Caravaggian aesthetic, has been preserved. Some of the most significant paintings from this period are:

The Placing of Christ on the Cross, in the Cogolludo Church of Segovia, Spain. A typical theme of Spanish painting reinterpreted by Ribera.

In 1626, he paints Saint Jerome (Hermitage Museum, Saint Petersburg, Russia) and Silenius Drunk (National Gallery of Capodimonte, Naples, Italy), in which the extreme tenebrist contrasts emphasize the mythological figure, a fat, pot-bellied drunkard.

In 1628, he executes Martyrdom of Saint Andrew (Museum of Budapest), an example of Ribera's consummate mastery of tenebrism, which he uses in a somewhat morbid intention to show the viewer dramatic or even horrible scenes or details.

In 1631, the Viceroy of Naples, Duke of Alcalá, commissioned Ribera to make a portrait of Magdalena Ventura, The Bearded Woman. The artist portrayed her next to her husband and with a child in her arms in one of the most pathetic works ever painted (Hospital de Tavera, Toledo, Spain).

For this same reason, his Prometheus Chained (1632, The Prado, Madrid) stands out. The god's body, seen in an incredible foreshortening, is surrounded by a frightening darkness from which emerges the crow, which is to rip out his entrails.

Ribera's change to a more personal style, slowly distancing himself from Caravaggio-style tenebrism, can first be seen in his Ascension of Mary Magdalene (1636, Academia de San Fernando, Madrid), a work in which he establishes his ideal of feminine beauty, later repeated in his Magdalene as an Adolescent (The Prado, Madrid) and adopted, among other artists, by Claudio Coello.

The extraordinary Pietà Ribera painted in 1637 (Saint Martin Monastery, Naples, Italy), the astonishing Martyrdom of Saint Philip and Jacob's Dream, of quiet atmosphere (both dated 1639 and in the Prado), bring to a close the transitional period toward a much more spontaneous style of lighter tones and less rigid definition.

Although the complete list of Ribera's works is very extensive and therefore cannot be included here, his mythological paintings must be mentioned, such as Venus and Adonis (National Gallery of Antique Art, Rome) or Apollo and Marsyas (Museum of Brussels). By the same token, his paintings of deformed people cannot be ignored either. These fall within the Spanish tradition represented by Velázquez and Carreño, the best example of which is probably The Bowlegged Man (Louvre, Paris).

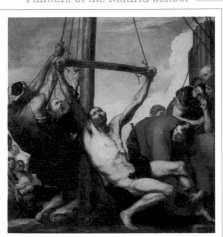

Ribera. Martyrdom of Saint Philip (1639). Oil on canvas, 91 1/4 × 91 1/4". The Prado, Madrid. Ribera's dramatism is perfectly enhanced by his emphatic use of the chiaroscuro technique.

Ribera. Jacob's Dream (1639). Oil on canvas, 91 × 69 7/8". The Prado, Madrid. Ribera's style turns toward a more gentle chiaroscuro and a less rigid definition.

Ribera. Repentant Magdalene (1641). Oil on canvas, 58 1/8 × 71". The Prado, Madrid. An ideal of feminine beauty that was adopted by other painters.

PAINTERS OF THE MADRID SCHOOL

The Madrid School is understood as the body of painting produced in Madrid after the first third of the seventeenth century. This results from the slow abandonment of Toledo as seat of the court in favor of Madrid, which slowly acquired the character and advantages of a capital city. The majority of the painters first integrating the Baroque School of Madrid had been working previously in Toledo. This school saw numerous good painters such as Juan Bautista Maino, the Rizi brothers (Juan and Francisco), and Herrera the Younger. Two of the greatest of these were Juan Carreño de Miranda and Claudio Coello.

Juan Carreño de Miranda

A Style with Affinities to Velázquez

Besides Velázquez, Juan Carreño de Miranda is the best representative of the Madrid School. His technique was very similar to that of Velázquez. He produced an Impressionist-type painting which turned away from the chiaroscuro to embrace a realism based on perspective, chromatic effects, and a simplified brushstroke. Burnt and earthen tones, and silvery gray predominated in his palette, which was only enlivened by various tones of carmine. This palette, closely related to his experiences as a fresco artist, reappeared in his easel paintings.

Born in Avilés in 1614, he moved to Madrid at age eleven. He began his painting studies under Pedro de las Cavas and Bartolomé Román, and later moved on to the studio of Francisco Rizi. In 1669, he was appointed painter to King Charles II, and in 1671, court painter.

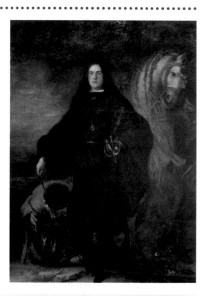

Juan Carreño. The Duke of Pastrana. Oil on canvas, 60¹/₂ × 84⁵/₈". The Prado, Madrid.

Juan Carreño. Eugenia Martínez Vallejo (The Monster). Oil on canvas, 41³/₄ × 64³/₈". The Prado, Madrid. Like Velázquez, Carreño also painted court dwarves.

Influenced by Titian, van Dyck, and Rubens, he created a notable production of religious paintings: *The Annunciation* and *Betrothal of Saint Catherine* (Hospital de los Terciarios, Madrid), *Mary Magdalene* (Academia de San Fernando, Madrid), and *Saint Sebastian* (The Prado, Madrid and Amsterdam Museum), all painted in 1653. Then came *The Founding of the Trinitarian Order* (1666, Louvre, Paris), *Saint Thomas of Villanueva Giving Alms to the Poor* (1675, Louvre, Paris), *Ecce Homo* (Cerralbo Museum, Madrid).

His Marian iconography portrayed models with a human character that distanced them from the idealized and sentimental images produced by many of his contemporaries. The *Assumption* (Poznán Museum, Poland), *The Coronation* (Descalzas Reales Convent, Madrid) and different versions of *The Immaculate Conception* are good examples. Carreño was perhaps the greatest portrait artist of 17-century Spain after Velázquez. His skill can be seen in his portraits of *Charles II* (The Prado, Madrid and the El Greco Museum, Toledo), *Count and Countess of Miranda* (Casa Torres Collection), *Duke of Pastrana* (The Prado, Madrid), among others.

Like Velázquez, he also painted buffoons and dwarves such as *Eugenia Martínez Vallejo* and *Francisco Bazán* (both at the Prado), tragic figures of the miserable court of the House of Austria's last king.

The Valencian José de Ribera
Painters of the Madrid School
Spanish Painters of the Eighteenth Century

6:

Claudio Coello

The Last Representative of Spanish Realism

This artist of Portuguese descent occupies a special place in the history of art in Spain: he is the last painter of Spain's Golden Age and he brilliantly closes the chapter of Spanish Realism. After his death in 1693, seven years before that of Charles II in 1700, Spain stops producing great painters until the arrival of Goya.

Coello's paintings, with realist representations of people, are nonetheless some of the most imaginative works of Spanish seventeenth-century art and the ones that best fit Baroque ideals. His figures, who almost always hold dynamic poses, are placed within a framework of landscapes, architectural scenes, or foregrounds with thick carpets, heavy curtains, and all sorts of drapery. They have an abundant pictorial materialism with gorgeously rich, clean colors, applied both in transparent and veiling layers of paint.

Born in Madrid in 1642, Coello entered Francisco Rizi's studio at a very young age and, through his friendship with Carreño, gained access to the royal collections, from which he copied many Rubens, van Dyck, and Titian originals. This indirect apprenticeship had a greater effect on the painter than his master Rizi's lessons. Upon the death of his friend and predecessor Carreño, he was appointed Charles II's court painter.

It is said that Coello died of sorrow in 1693 upon losing the king's favor to the newly arrived Italian, Luca Giordano.

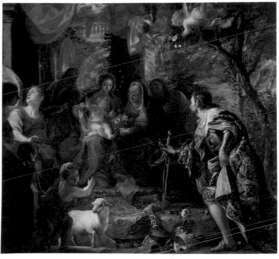

Coello. The Virgin and Child Worshiped by Saint Louis, King of France, and Other Saints *(circa 1665–1668). Oil on canvas, 97 1/8 × 89 3/8". The Prado, Madrid.*

Coello. The Adoration of the Holy Eucharist by King Charles II and His Court. *Oil on canvas, 117 × 195". El Escorial Monastery, Madrid.*

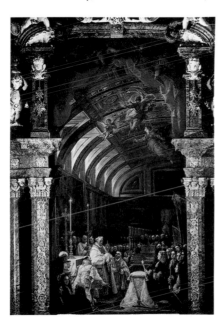

Of Coello's religious paintings done on easel, the most remarkable are the following:

The Triumph of Saint Augustine (1664, The Prado), a painting from his early period; *The Martyrdom of Saint John* (1674, Ciempozuelos, Madrid); and *Mary Magdalene* (1682), based on the model created by Ribera (There is a copy in the Prado Museum, whereas the sketch is in the Museum of Cádiz).

The Virgin and Child Among the Theological Virtues and Saints, as well as *Saint Louis Worshiping the Virgin and Child* are two important paintings along the lines of the contemporary Italian *sacra conversazions.*

Coello's two most representative works are *Saint Theresa's Last Communion* (Lázaro Galdiano Museum, Madrid) and *The Adoration of the Holy Eucharist* (Sacristy, El Escorial Monastery). This is a large-format painting (117 × 195") containing about 50 portraits of court figures including that of Charles II, (the Dukes of Medinaceli and Pastrana, the Count of Baño, the Marquis of Puebla) as well as the painter's own self-portrait. It is a beautiful example of late Spanish Baroque Realism.

As a portrait artist, Coello uses a realism without concessions. This is apparent in *Mariana of Austria* and *Mariana of Neuburg* (The Prado, Madrid), *Charles II* (also in the Prado), and many others as well.

SPANISH PAINTERS OF THE EIGHTEENTH CENTURY

After the death of Charles II, the arrival of the first king of the Bourbon Dynasty brought radical changes to all aspects of life for the people in Spain. The centralist idea of state imported from France brought political and administrative uniformity, with profound repercussions in the cultural world. Within this framework, the quality painting produced under the first Bourbons was, so to speak, imported. Philip V called the French painters of his predilection to his court (Jean Ranc and Louis Michel van Loo), whereas Ferdinand VI and Charles III preferred Italian painters: Amigoni, Giaquinto, Tiépolo, and Mengs, who, although not Italian, painted in an Italianate style.

Painting of Spanish Origin

These changes, however, did not mean the total extinction of the previous pictorial tradition. We will therefore mention the most notable of the artists who continued that tradition.

Antonio Acisclo Palomino de Castro y Velasco

His Works

Although he is little known and appreciated today, he was one of the most remarkable theoreticians of drawing of the seventeenth and eighteenth centuries, and it is only fair to recognize him, particularly since there were few Spanish art theoreticians in the Baroque period.

He was born in Bujalance, Spain, in 1655 and studied theology, philosophy, and jurisprudence in Madrid. He had a wide knowledge in the humanities and was a great student of the theory of drawing. An admirable portrait artist and religious painter, the history of art is indebted to

him for his treatise, a considerable contribution to art theory called *The Pictorial Museum and Optical Scale*. In it, he establishes the theoretical principles of drawing and painting and writes the biographies of the most renowned Spanish artists, a source of great historical value.

Of his pictorial works, the most noteworthy are his frescos for the Cathedral of Salamanca (1705) and the decoration of the Temple of the Santos Juanes of Valencia. After his wife's death, and a year before his own death in 1726, he entered the church.

Luis Eugenio Meléndez

His Works

Son of a miniaturist, Luis Eugenio Meléndez was born in Naples in 1716. His family soon moved to Madrid, where he studied under his uncle, Miguel Jacinto Meléndez, court painter.

After returning to Madrid from a trip to Rome and Naples, he began to work in the court as book illustrator for the Royal Chapel.

Luis Eugenio Meléndez. Bodegón: Box of Sweets, Pastry, and Other Objects (1770). Oil on canvas, 14 1/2 × 19 1/8". The Prado, Madrid.

The failure of his efforts to be appointed court painter to Charles III does not reflect on his talent as a portrait artist, which was quite remarkable, as can be seen in his *Self-Portrait* (1746, Louvre, Paris), the best 18th-century Spanish portrait before the appearance of Goya. Nevertheless, Meléndez's great contribution was his still-life painting, which continued in the tradition of Zurbarán and Velázquez. Painted on dark or neutral backgrounds, the elements of his compositions, profoundly popular in origin, reveal a conceptual elegance hardly equaled in a genre little practiced by his contemporaries. Nearly fifty still lifes (or *bodegónes*) by Meléndez adorned Charles III's palace in Aranjuez.

Luis Eugenio Meléndez. Bodegón: Red Bream and Oranges (1772). Oil on canvas, 16 3/8 × 24 1/8". The Prado, Madrid.

Painters of the Madrid School
Spanish Painters of the Eighteenth Century
Peter Paul Rubens

65

Luis Paret y Alcázar

His Works

Luis Paret y Alcázar is one of those artists who has only begun to be appreciated in the 20th century. Critics have learned to value the originality of a painting, Rococo in spirit and "modern" in brushstroke. It has been said of Paret's small-format works, of porcelain characteristics, that they resemble slightly enlarged miniatures.

His religious works for the Chapel of Saint John the Baptist in Viana, Spain, are outstanding. But his most representative works portrayed scenes of courtly or bourgeois life painted for the king and for the Crown Prince Luis, as well as on private commission. *The Antiquarian Shop, Rehearsal for a Play, A Stroll Along the Botanical Gardens,* and *Charles III Eating Before His Court* are works which bespeak Paret's refinement. *Celestine and the Lovers* is an exquisite watercolor that, along with the *Paintings for Crown Prince Luis' Natural History Album,* reveals Paret's mastery of this technique.

The Bayeu Brothers

Their Works

Francisco, who was born in Zaragoza and died in Madrid (1734–1795), is the most famous of the three Bayeu brothers. In keeping with the artistic tastes of the time, he was an enthusiast of

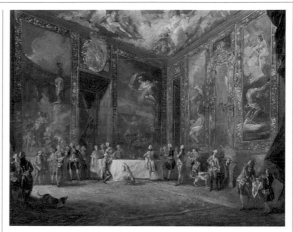

Luis Paret y Alcázar. Charles III Eating Before His Court *(circa 1770). Oil on canvas, 25 × 19¹/₂". The Prado, Madrid. This small and lovely painting has all the appearance of a miniature.*

both Luca Giordano and Corrado Giaquinto. He assisted in the decoration of the royal palace in Madrid with his fresco *The Defeat of the Giants* for one of the ceilings. He directed the San Fernando Academy of Fine Arts and, in the last years of his life, concentrated on the art of portrait painting. A lovely result of this activity is the *Portrait of Feliciana Bayeu* (1788), displayed in the Prado, Madrid.

Ramón did not share his brother's enthusiasm for mythological and religious compositions. He preferred popular scenes of marked realism and was, alongside his brother-in-law Goya, one of the principal artists for the Santa Bárbara Tapestry Factory.

Brother Manuel, though considered "the painter" of the family, is a figure of whom we know little, except that he became a Carthusian monk. He executed large narrative cycles for the Carthusian Monasteries of Aragón and of Valldemosa, Mallorca, some of the paintings of which can be seen in the Museum of Huesca, Spain.

Francisco Bayeu. Olympia: The Fall of the Giants *(circa 1764). Oil on canvas, 48 × 26¹/₂". The Prado, Madrid. A work in the style of the great Italian muralists, which he repeated as a fresco in the royal palace.*

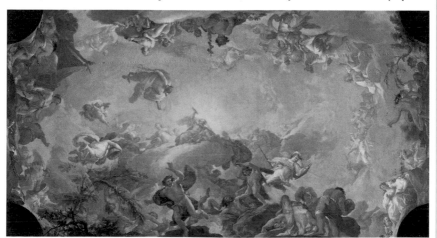

PETER PAUL RUBENS

The religious wars of the second half of the 16th century brought about the artistic decline of Flanders. By 1600, the provinces became Catholic, Spanish-dominated, Flemish and Wallons to the south, and independent Dutch Calvinist to the north. Flanders recovered its artistic genius with painters commissioned by Spanish kings and patrons.

The Painting of Peter Paul Rubens

Rubens is the artist who best represents the new impulse of Flemish painting. He was perhaps the most renowned painter of his time, as well as the one who most enjoyed the benefits of his art. With his many resources and acquaintances—kings, great merchants, high dignitaries of the church and the political world— Rubens was constantly sought out. With the assistance of painters as talented as van Dyck and Jordaens, he worked at a frenzied pace. In more than 2,500 known paintings, he recreated in his own style the enduring charm of great Italian art.

Rubens was absolutely faithful to the spirit of Baroque art, even to a far greater extent than the Italian Baroque.

Rubens. The Three Graces *(circa 1636–1638). Oil on canvas, 46 × 86 1/2". The Prado, Madrid.*

Tenacious copyist of Caravaggio, Tintoretto, Titian, and Veronese, Rubens acquired from them a taste for color and compositional dynamism. His own style is monumentalist, dominated by colorism, pompous forms, and a frenetic dynamism of composition, which connects figures through a curvilinear structure ordered according to the diagonals of the painting. He added a new model to the iconography of the feminine nude, very rich in rhythm, with a generous amount of flesh, yet which seems to the spectator to be capable of incredible agility. Such an intense life as Rubens's is difficult to summarize. It is presented chronologically, with no distinctions.

Rubens. Hélène Fourment in Wedding Dress *(1630–1631). Oil on canvas, 53 3/8 × 63 3/4".* Alte Pinakothek, Munich. Brocades, pearls, *precious stones. . . all the requisites for a princely Baroque portrait.*

THE ARTIST'S LIFE

1577. He is born in Siegen, Westphalia, Germany, son of Jan Rubens, a middle-class doctor of law who lives exiled in Cologne.

1589. After the death of his father in 1587, the family settles in Antwerp where Peter Paul attends the Verdonck School, studying under Balthasar Moretus.

1590–1596. He spends these years as an apprentice, first to Tobias Verhaecht, then to the painter Adam van Noort (1557–1641), and finally to Otto van Veen (1556–1629). In 1598, he attains the status of master.

1600. Thanks to the protection of Archduke Albert, he visits Venice, Florence, and Mantua. Vicenzo Gonzaga, Duke of Mantua, contracts him as court painter.

1603. The Duke of Mantua appoints him ambassador to Philip III. He takes advantage of his trip to Spain to visit the royal collections, copy Titian, and paint his *Equestrian Portrait of the Duke of Lerma* (1603, The Prado).

1608. He returns to Antwerp on his mother's death. A year later, at the age of 32, he marries Isabella Brant. In 1611, his daughter Clara Serena was born, and in 1614, his son

Albert. Rubens enters a period of maturity in his painting. In 1612 he finishes the tryptic *Descent from the Cross* for the Cathedral of Antwerp, which brought him popularity and public recognition. In this period he paints *Saint Thomas Doubting, The Last Judgment* his famous mythological works *Silenus Drunk* (1616–1618) and *The Rape of the Daughters of Leucippus* (1616–1618). In 1619 he paints one of his most remarkable compositions, *The Fall of the Condemned* (all in the Alte Pinakothek, Munich).

1622. He travels to Paris to decorate one of the main galleries of the Luxembourg palace. The series of *Allegories on the Life of Queen Marie de Médicis* is one of his most representative works (Louvre, Paris). At this time he also paints the portrait of his wife, *Isabella Brant* (1624).

1626. His wife dies. Commissioned by the Archduchess Isabel Clara Eugenia, he carries out tapestry cartoons on the theme *The Triumph of the Eucharist* for the Descalzas Reales Convent in Madrid. At the same time, he paints the portraits of *Marie de Médicis* and *Anne of Austria*, on

display in the Prado.

1628. On his second trip to Madrid, he meets Velázquez. Diplomatic missions bring him to Brussels and London, where Charles I grants him the title of Sir.

1630. He returns to Antwerp and, at 53, marries sixteen-year-old Hélène Fourment, with whom he has five children. There are portraits of Hélène in the museums of Amsterdam, Florence, the Louvre, Naples, the Hermitage, and Berlin. She appears in all sorts of attire, playing with her children, dressed in formal etiquette, nude, or coming out of the bath. She is the attractive woman (or perhaps it is her sister) who poses for one of his most celebrated portraits, *The Straw Hat*, at the National Gallery in London.

1635. At this time he buys Steen Castle, where he paints astonishing landscapes, among others, *Philemon and Baucis in a Tempest* (Kunsthistorisches Museum, Vienna). *The Kermess* is from 1636 (Louvre) and *The Three Graces* from 1639 (Prado).

1640. He dies in Antwerp, having achieved great fame.

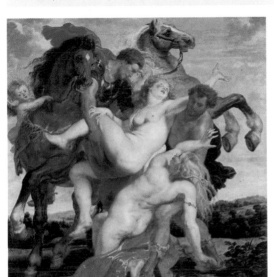

Rubens. The Rape of the Daughters of Leucippus *(circa 1618). Oil on canvas, 82 × 87³/₈". Pinakothek, Munich. A compositional solution of enormous dynamism for a brilliant painting.*

Rubens. Marie de Médicis, Queen of France *(1622–1625). Oil on canvas, 42¹/₈ × 50³/₄". The Prado, Madrid. A royal portrait with atypical light solutions.*

VAN DYCK AND JORDAENS

Rubens's overwhelming success and prolific production would not have been possible but for the collaboration, more or less enthusiastic, of the magnificent painters who worked alongside him. Some of them, first-rate painters themselves, achieved a well-deserved fame like their master. Van Dyck and Jordaens are the most prominent of these.

Anthony van Dyck

Along with Rubens, he represents the height of seventeenth-century Flemish Baroque. Besides his intrinsic value, van Dyck stands out for having left his country to settle in England. There he produced a most important and admired work which served as a catalyst, causing the lethargic artistic world of Great Britain to react. Van Dyck's example was the impulse behind the exquisite British painting school of the eighteenth century.

Van Dyck was, above all, an elegant painter, with a style uniting the rich impastos of Rubens, applied with an agile and certain brushstroke, with the bright colors of the Venetian painting he so admired. His name has become inextricably related with portrait painting but, as a painter of his times, he also had to produce religious and mythological works. In his religious production, van Dyck adopts a Caravaggio-style dramatism, with a fever-pitch chiaroscuro.

Van Dyck. Charles I in Hunting Attire (1635). Oil on canvas, 82⅝ × 106". Louvre, Paris. This is one of van Dyck's most emblematic works and, according to the experts, his finest portrait, in which he combines his sense of elegance and outstanding mastery of light and color. This painting, which belonged to the collection of Louis XIV, laid the path for the future triumph of the English portrait.

The artist worked mostly in England, where he left 350 paintings. His portraiture is very extensive: to mention only the royal family portraits, he painted 24 of King Charles I (seven are equestrian), 25 of Queen Henrietta Mary, and various groups of the royal children.

Outstanding are *King Charles I with Queen Henrietta, Prince Charles and Princess Mary* (1632, Windsor Castle), *Equestrian Portrait of the King* (1633, Windsor Castle), and *King Charles I at the Hunt* (1635, Louvre, Paris), doubtless one of the best portraits ever painted, *The King Dressed as*

THE ARTIST'S LIFE AND WORK

1599. Anthony van Dyck is born in Antwerp. He receives his first lessons from Hendrik van Balen. At fifteen, he has already surpassed his teacher and has established his own studio.

1618. He is admitted as master to the Antwerp painters' guild.

1620. He works alongside Rubens on the decoration of the Antwerp Jesuit Church. He travels to Genoa, Rome, Venice, and Sicily, where he works with great success.

1622. He travels for the first time to Britain and, among other works, paints the *Portrait of the Count of Arundel* and *King Jacob I.* Upon failing to attain the success he had hoped for, he returns to Antwerp and enters a period of reflection and improvement.

1627. Charles I of Britain invites him to London. He establishes himself in a studio on Blackfriars, where the king himself visits him and asks him to come to the court. The artist is received on equal

terms by the British aristocracy and married one of Lord Ruthven's sisters, from an important Scottish family.

1636–1641. Van Dyck travels first to Antwerp (1636) and then to Paris (1640) when the political events that led to the execution of Charles I begin to complicate matters in British high society. Not at home in France, he soon returns to London, where he dies in 1641. He is buried in Saint Paul's Cathedral.

Knight of the Order of the Garter (in Windsor), and another *Equestrian Portrait of Charles I* (National Gallery, London).

In addition to these and his many other portraits of great historical figures, van Dyck produced such extraordinary mythological paintings as *Cupid and the Sleeping Nymph, Icarus*

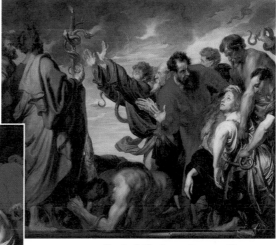

Van Dyck. The Bronze Serpent. Oil on canvas, 91⁵/₈ × 80". The Prado, Madrid.

Van Dyck. The Crown of Thorns (circa 1620). Oil on canvas, 76¹/₂ × 87". The Prado, Madrid. The Flemish artist's use of Caravaggian dramatism is evident in these two paintings.

and *Dedalus, Reinhold and Armilda.* Of his religious works, all of great beauty, the most remarkable are: *The Bronze Serpent* (The Prado, Madrid), *The Crown of Thorns* (1620, The Prado), *Mary Magdalene* (1618, Musée des Beaux Arts, Bordeaux) —the work of a young van Dyck with the unmistakable influence of Rubens's aesthetic—and others.

Jacob Jordaens

Of all the Flemish painters of the seventeenth century, Jordaens (1593–1678) is the one who remains most faithful to Rubens's aesthetic ideas, whom he admired all his life. Nevertheless, he is very different in temperament. He never left his country and, through-

out his life, asserted his preference for a deeply nationalist painting.

His palette kept the luminosity, colorism, and impasto of his admired Rubens but, in subject matter, Jordaens did not reach for the heavens but stayed firmly anchored on the ground, reproducing scenes of daily life in his country.

Even in his mythological paintings, Jordaens's propensity for the popular, with a flavor of the jocose, emerges in works such as *The Baby King* (1638–1640, Louvre, Paris) or, with a different theme,

Melanion and Atalanta (circa 1628), where the mythological figures are represented by popular types.

Besides his ample repertoire of easel paintings, Jordaens also drew several tapestry cartoons and, beginning in 1640, carried out an ambitious plan for the decoration of Greenwich Palace.

In 1648, he became the official painter to Queen Christina of Sweden and, commissioned by Frederick Henry, worked in the *Huis ten Bosch,* the royal villa near the Hague.

Jacob Jordaens. The Baby King (circa 1640). Oil on canvas, 81⁷/₈ × 60⁷/₈". Museum of Fine Arts, Brussels. Jordaens painted at least four versions of this same theme. In them, he recreated lively and festive scenes with gruesome details and a somewhat formal quality. The composition centers interest on the person who has been declared king of the festival on the Epiphany.

THE "MINOR" MASTERS

The term "minor master" is often used by art historians to refer to artists who, although they were true masters in their fields, have been overshadowed by the huge fame achieved by their contemporaries. It is easy to mistakenly interpret the term "minor master" as pejorative. Many of these masters were great artists, held in high esteem by the society of their time. Although they may not have been geniuses in their field, a classification granted to only a special few, they were nonetheless leading artists. Considered minor masters in seventeenth-century Flemish painting are artists such as David Teniers, Frans Snyders, Paul de Vos, and Joannes (or Jan) Fyt. We will close our brief summary of the Flemish Baroque with a look at these artists.

David Teniers the Younger

The Greatest Genre Painter of Flanders

David Teniers the Younger (1610–1690), a profound observer of common people, left to posterity a complete description of rural and urban life in his era. His repertoire included kermess or country festivals, entrances of important people, shooting contests, processions, and tavern interiors with a wealth of picaresque scenes. In his subject matter, Teniers was very much in keeping with Flemish bourgeois tastes. He was highly appreciated by various European monarchs as well. Teniers had become court painter to Archduke Leopold William and the regent often gave paintings by Teniers as gifts to

David Teniers. The Old Man and the Servant *(circa 1650). Oil on canvas, 35 × 21¹/₂". The Prado, Madrid. Teniers's interiors reveal the presence of everyday objects with a chromatism and detail of the highest quality.*

other monarchs. Philip IV of Spain, Christina of Sweden, and William II of Orange had works by Teniers hanging in distinguished places in their collections. Stylistically speaking, Teniers reevaluated the treatment of everyday objects to create a meticulous style with a chromatism based on ochres, grays, silvers, browns, and carmine. His abundant production can be found dispersed throughout museums such as the Prado in Madrid, the National Gallery in London, the Dresden, Amsterdam, and Berlin museums, the Hermitage in St. Petersburg, the Louvre.

Frans Snyders

Frans Snyders was the maximum exponent of the Flemish still life. The representation of ordinary objects, kitchen utensils, various earthenware objects and food, which in Flemish religious painting had been placed in a corner of the painting to demonstrate the painter's skill, began to emerge as a genre in and of itself in the mid–sixteenth century, reaching its age of splendor with Frans Snyders (1579–1657).

David Teniers. Village Festival *(1640–1660). Oil on canvas, 33¹/₂ × 27". The Prado, Madrid. In Teniers's kermess, the passive presence of bourgeois figures contrasts with the great vitality of the village folk, portrayed with realism and respect.*

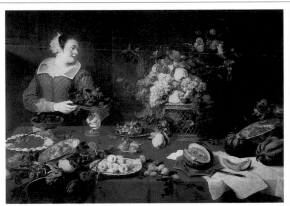

*Frans Snyders. The Fruit Vendor. Oil on canvas, 83 1/2 × 59 5/8".
The Prado, Madrid. Snyders is the great seventeenth-century
master of still lifes and hunting scenes, frequently with a human
presence. He was a key figure in the development of the genre.*

Educated in the Brueghel tradition (he had been apprentice to Pieter Brueghel the Younger), he knew how to transform objects and foods into a genre of luxurious decorativism. His first still lifes were of fruit, but in time, he showed a preference for hunting themes with abundant portrayal of game: peacocks, hare, partridge, antelopes, with the addition of seafood, fruit, and vegetables. In some of his best canvasses, the still life is complemented by the presence of a person (a servant holding a dead animal, for example), as if to attenuate the macabre connotations of so much death with their implied participation in culinary tasks. A magnificent example is the *Still Life* in the Valenciennes Museum, France.

His principal clients were King Philip IV of Spain and, after him,

Archduke Leopold William. The Prado Museum in Madrid has a magnificent collection of Snyders's work, among which is the *Fable of the Hare and the Turtle*, an illustration of Aesop's story in which a background landscape shows the influence of Jan Wildens (1584–1653), the artist who painted Rubens's background landscapes. *Concert of Birds* can be seen in the Prado, and *Dogs, Cats, and Other Animals* in the Hospital de Tavera, Toledo, Spain.

Done in the first half of the seventeenth century, *Fruit and Animals* (Louvre, Paris) is one of Snyders's nonhunt-related still lifes. In it, Snyders went beyond the usual meticulosity of still-life paintings of that time and sought a Baroque effect and thematic unity in a composition that appears anarchic but was actually carefully studied.

Paul de Vos and Joannes Fyt

Our chapter on the minor masters of Flemish Baroque closes with a brief mention of Paul de Vos and Joannes (or Jan) Fyt, considered the most important followers of Snyders's work. The former was involved with hunting themes, whereas the latter was concerned with Realism in his still lifes, showing a greater penchant for decorativism than Snyders.

De Vos (1596–1678) worked with Snyders, his brother-in-law, as an assistant to Rubens in his commissions for Philip IV of Spain. He was under direct instructions from Rubens and was therefore influenced in his composition and use of colors.

As a painter of hunting scenes, he was highly concerned with anatomy, and his animals always appeared vigorous and dynamic. Some of his compositions have acquired great popularity with time and have been copied again and again.

Joannes Fyt (1611–1661) was the most direct follower of the Snyders school. Like his master, he wanted to demonstrate his skill at painting the human figure, which he included in some of his still lifes, but always as an accessory and never as the centerpiece, reserved for tables replete with all sorts of foods. Fyt's still lifes were present in all the main art markets of Europe.

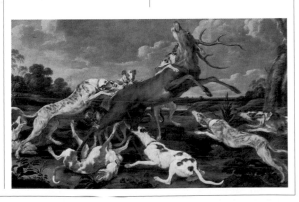

*Paul de Vos. Deer Beset by
a Pack of Hounds. Oil on canvas,
135 3/8 × 82 5/8". The Prado,
Madrid. Famous for his hunting
scenes, De Vos always showed a
concern for animal anatomy.
He was able to lend vigor and
realism to his animal figures
within compositions reminiscent
of Rubens and Snyders.*

FRANS HALS

In 1581, the low countries of the north, republican and with a Protestant majority, became independent from the Spanish monarchy. The Protestant provinces, seed of the future Netherlands, reinforced a culture emerging from commercial prosperity and the development of urban life, controlled by civic and professional corporations. This was to have major repercussions on Dutch art, which lost all contact with artistic centers to the south and, in content and expression, acquired a personality of its own. Frans Hals contributed to this like no other painter.

The Painting of Frans Hals

Frans Hals was the most genuine representative of the group portrait tradition, initiated in the 16th century by van Scorel (1495–1562) and developing until Cornelis van Haarlem (1562–1638). His paintings, free of the allegorical values so prized in the French and Flemish Baroque, presented the objective viewpoint of the historian who, on large canvasses, immortalizes an instant in the life of middle-class members of guilds and other civic corporations. Hals "catches" them in the middle of their meetings or collective activities, whether political in nature or simply for cameradery. He liked portraying groups at banquets. These large-format paintings were paid for by the people portrayed in them.

Frans Hals. Portrait of Paulus van Beresteyn *(circa 1620). Oil on canvas, 40½ × 53⅜". The Louvre, Paris. This portrait was done during the first year of Hals's golden period.*

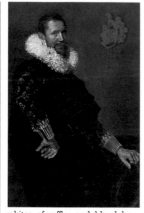

In his "banquets" and other group portraits, Frans Hals revealed his great mastery of composition. The figures involved are each treated equally within the collective scene. They hold conversations, gesticulate, drink, and laugh; each is portrayed with his individual personality, yet all contribute to the unity of the painting. Monotony was avoided by placing the people in small groups along the diagonals of the painting and around a centerpiece of secondary importance, such as a table or a window. Hals's brushstroke was thick and his chromatism exultant. Reds, yellows, and blues contrast with the subdued whites of ruffles and blond lace collars on figures who, whether in group or individual portraits, were the result of spontaneous drawings. Their pose and the perspectives were the direct expression of observed reality.

Frans Hals. Banquet of Officers of the Civic Guards of Saint George at Haarlem *(1616). Oil on canvas, 126⅜ × 68¼". Frans Hals Museum, Haarlem, Netherlands. In this group portrait, Hals demonstrates his extraordinary talent for avoiding any possible monotony in the composition, by cleverly placing people in groups and uniting them visually, in this case with the diagonal traced by the banner in the background.*

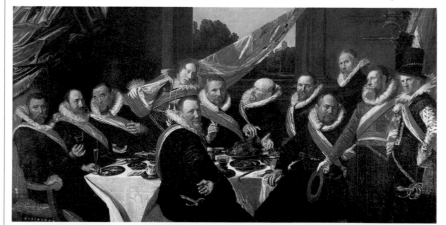

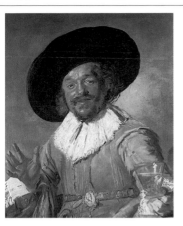

Frans Hals. The Merry Drinker *(1628–1630). Oil on canvas, 26 × 31¹/₂". Rijksmuseum, Amsterdam.*

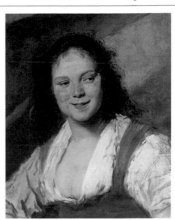

Frans Hals. The Gypsy Woman *(circa 1628). Oil on canvas, 39 × 53¹/₂". The Louvre, Paris.*

THE ARTIST'S LIFE

Between 1581/85. Frans Hals is born in Antwerp, though his parents were from Haarlem. By 1591, young Frans is living in Haarlem, in the Netherlands.

1611. He paints his first signed work: *Portrait of Jacobus Jaffius*, an oil on panel now in the Frans Hals Museum in Haarlem. Although influenced by other portraitists of the time, this work shows the same parallel and zig-zag brushstrokes that would become characteristic of his later work.

1615. He begins to produce genre paintings with his *Carnival-goers* (Metropolitan Museum, New York).

1616. He paints his first large group portrait: *Banquet of Officers of the Civic Guards of Saint George at Haarlem*. This work, in the Frans Hals Museum, is his first large "banquet" painting and it already presents the compositional characteristics that Hals will use in all future ones. Between 1616 and 1660, Hals paints nine large group portraits.

1620. This year marks the beginning of his most productive period, which lasts until 1650. During this time he reaches artistic maturity in both group and individual portraits. The most representative ones include: *Paulus van Beresteyn* (1620, Louvre, Paris), *Caterina Both van der Eem* (1620, Louvre, Paris), *Yonker Ramp and His Fiancée* (1623, Metropolitan Museum, New York) and *The Laughing Cavalier* (1624, Wallace Collection, London). These are examples of the vitality and optimism of Hals's portraiture.

1627. He produces another of his most famous group portraits, *The Banquet of the Officers of the Civic Guard of Saint Andrew*. In the same style as the first one, it is remarkable for its "snapshot" spontaneity, its composition (directed along the two diagonals of the painting) and the detailed study of each figure's personality shining through in a moment of euphoria. This canvas of spectacular chromatic effects is a key to understanding the character of the Dutch Baroque.

1628–1630. He paints *The Gypsy Girl* (Louvre, Paris) and *The Merry Drinker* (Rijksmuseum, Amsterdam), two of the most spontaneous and authentic portraits ever painted. They are surprising for their extremely modern character.

1641. In one of his frequent periods of financial and spiritual hardship, he paints *The Regents of the Saint Elizabeth Hospital* (Frans Hals Museum, Haarlem). The hardships he suffered and later overcame are reflected in his painting— very sober, with cold shades of black, grey, and ochre, more poetic and of deeper psychological penetration.

1664–1666. As an octogenarian, he reaches a truly dramatic sobriety in which black becomes the protagonist. *His Portrait of a Man with Slanted Hat* (Kassel Museum, Germany), painted between 1660 and the year of his death, shows that chromatic exuberance has given way to melancholic intimacy. This final development acquires great significance in his last group portrait, painted in the elderly home where, in 1666, he ended his days: *The Governors of the Old Men's Home at Haarlem* (1664, Frans Hals Museum, Haarlem). With absolute predominance of black and white, it is one of the masterpieces of Dutch painting.

REMBRANDT VAN RIJN

Of all great painters, Rembrandt perhaps most contributed to defining the concepts
which characterize modern painting. He has been called *the creator of the
modern concept of the sublime.* He preached and practiced the idea that
the aesthetic value of a work of art, and particularly of a painting, does
not depend on the object represented. Even the ugliest of subjects
can be made sublime if it is the object of a work of art.

Rembrandt's Painting

To arrive at a first approx-
imation of his art, heavily
influenced by the vicissitudes of his
life, we shall divide it into the three
periods established by art
historians, in which his aesthetic
ideas mature and his unique
technique progressively improves.

The Early or
Formative Period

Rembrandt's precociousness
allowed him to paint from a very
early age in his own studio in
Leiden, where he worked from
1625 to 1631. What is considered
as his first period stretched from
1631 to 1640, when he was living
in Amsterdam. His early style
showed a heavy influence of
chiaroscuro technique, a result of
his observation of painters from

Utrecht who followed Cara-
vaggio, as well as Rubens's ideas
on light.

During his time in Leiden, he
took the art of engraving to a
height that has never been
matched.

The following works date from
this period:
 – *Stoning of Saint Stephen*
(Lyon Museum, France)
 – *Tobias and Anna*
(Rijksmuseum, Amsterdam)
 – *The Flight into Egypt* (Tours
Museum, France)
 – *Saint Paul in Prison* (Stuttgart
Museum, Germany), painted in
1627 for an art collector named
Huygens
 – *Portrait of Maurice Huygens*
(Hamburg Museum, Germany).

The happiest stage of the
painter's life took place in
Amsterdam, where he lived
between 1631 and 1642, after
marrying Saskia. He began work-

Rembrandt. Self-portrait with
Gorgrt and Cap. *Oil on canvas.
Of the self-portraits of the young
and enthusiastic Rembrandt, this
one perhaps reveals the most
profound psychological aspects
and achieves the luminosity
characteristic of his backgrounds.*

ing as a portraitist. Rembrandt
brings the portrait to the very front
of the painting, within a
chiaroscuro in which light
dissolves and adds highlights,
lending the flesh textures of
extraordinary subtlety. His
portraits were usually of the upper
body, perhaps because this
allowed the artist to center his
interest exclusively on the head,
to penetrate, as it were, into the
psychology of the subject, and to
concentrate on color and relief
using generous amounts of paint.
Following are some of the most
important paintings from this time.
 – *Saskia with a Veil* (National
Gallery of Art, Washington D.C.)
is perhaps the most outstanding
work of this period.
 – *The Painter Offers a Toast
with Saskia on his Lap* (Pinakothek,
Dresden), is one of Rembrandt's
most optimistic pieces, a sincere
expression of the couple's happi-
ness.
 – *Anatomy Lesson of Dr.
Nicolaes Tulp* (1633–1635,

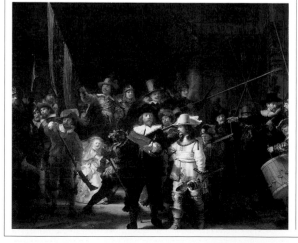

Rembrandt. The Militia Company of Captain Frans Banning Cocq
(the falsely named Night Watch), *1642. Oil on canvas, 170⁷/₈ × 140".
Rijksmuseum, Amsterdam. Doubtless his most famous painting as
well as one of the most ambitious compositions for a group portrait.*

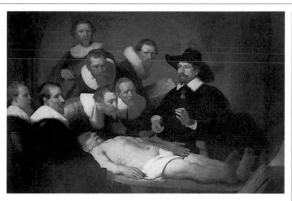

Rembrandt. Anatomy Lesson of Dr. Nicolaes Tulp (1633–1635). Oil on canvas, 84 1/4 × 66". Mauritshuis, The Hague. A group portrait from his first period in Amsterdam in which he demonstrates his skill in composition and in capturing facial expressions.

Mauritshuis, The Hague) is one of his first group portraits as well as one of his most renowned works.

In this period he also produces some of his most Baroque-spirited religious and mythological works, both paintings and engravings, such as:

– *Descent from the Cross* (Alte Pinakothek, Munich), one of the painter's conceptually most Baroque works.

– *Samson Blinded by the Philistines* (Staedel Institute, Frankfurt), a painting intended to produce a strong impression on the observer when viewed from a certain distance under strong light.

– *Rape of Ganymede* (Picture Gallery, Dresden), one of Rembrandt's most well-known mythological works.

– *Danae* (The Hermitage, St. Petersburg).

In all of these works Rembrandt uses a tremendously moving chiaroscuro.

The Second or Transitional Period

During a transition period (1640–1647) that began after his marriage, Rembrandt intensified his artistic endeavors and became somewhat eclectic. His painting was affected by diverse Baroque currents, from the dynamism of Rubens to the

Classicism embodied by Poussin. These influences led Rembrandt to a deeper interpretation of chiaroscuro, which lent spiritual connotations to the serene dramatic character of his art, perhaps in a spontaneous reaction to the sorrow he felt at his wife Saskia's death in 1642.

Some of his largest and most famous paintings date from this period.

In fact, his most famous painting of all is from 1642.

– *The Militia Company of Captain Frans Banning Cocq*,

known as *The Night Watch*. It is a canvas 170 7/8 × 140" in size, whose style oscillates between French Classicism and Rubenesque dynamism. Each one of the people portrayed in the painting contributed 100 florins. The painting hung in the central vestibule of the harquebusiers' barracks in Amsterdam until 1715, when it was moved to the city hall. The painting was cut down in size because the new location was not large enough. The original appearance of the painting is therefore unknown. In addition, a recent cleaning has shown that it is not a night scene at all. On the contrary, it takes place in full daylight! This work has a rich coloring, with the predominance of an extensive range of light yellow hues. Several of his biblical scenes were done at this time as well, such as:

– *The Adulteress* (National Gallery, London)

– *The Good Samaritan* (Louvre, Paris)

– *The Disciples at Emmaus*, a subject Rembrandt painted several versions of. The one from 1648 (Louvre, Paris) is considered to signal the beginning of his mature period, when he began to use lavish earthy primers and a layering technique.

Rembrandt. The Syndics of the Drapers' Guild (1662). Oil on canvas, 108 7/8 × 74 1/2". Rijksmuseum, Amsterdam. Seven years before his death, Rembrandt executed this exemplary work: the six protagonists share the same weight within a pleasant and ductile composition.

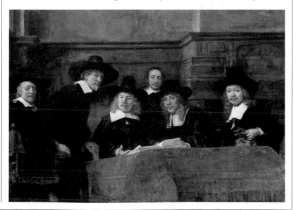

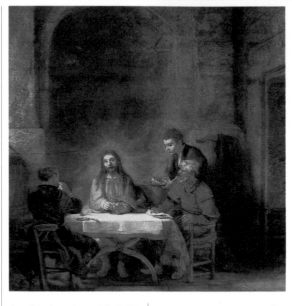

Rembrandt. Christ at Emmaus (1648). Oil on panel, 25³/₈ × 26¹/₂". Louvre, Paris. This panel represents an important turning point in Rembrandt's style. He begins to use earthy primers and applies layers of paint which provide a light characteristic of his mature works.

The Third or Mature Period

In 1648, Rembrandt began to paint technically more complex works showing great pictorial ability, with richer chromatism and the application of extraordinarily effective layers. He applied an earthy primer of ochre combined with an animal resin similar to that used by Titian. He was thus obliged to work with darker colors covering lighter tones. He painted without preliminary studies, executing his compositions from a monochrome prepainting indicating light, shadow, and shine. He would then apply the principal colors, beginning with the background and progressing to the foreground, but keeping the figures in the original monochrome state. Lastly, he modified the figures with successive layers which would emphasize contours and shapes, finishing with the extraordinary sheens that distinguished and enriched his chromatism.

As is the case with many great artists, this period of pictorial maturity coincided with the time of greatest sorrow, financial need, and spiritual decline in his life. For this reason, Rembrandt concentrates on sensitive portrayals of human beings. He paints self-portrait after self-portrait as if attempting to delve deeper into his own self before the mirror.

From 1648 to 1660 he produced, among many other works, four of his most significant pieces:

– *Aristotle Contemplating the Bust of Homer* (1653, Metropolitan Museum, New York), one of the best examples of Rembrandt's most developed style.

– *Bathsheba* (1654, Louvre, Paris). This is one of Rembrandt's most famous nudes.

– *Woman Bathing*, or *Hendrickje* (1655, National Gallery, London). This is a small-format painting (18³/₈ × 24¹/₈") done in amazingly free, yet precise brushstrokes, unthinkable for a painter of the seventeenth century.

– *The Slaughtered Ox* (1655, Louvre, Paris). This subject matter is utterly atypical (even more so in the middle of the Baroque period) treated with an absolutely "modern" pictorial idea.

In his last decade of life (1661–1669), though he experienced many setbacks, Rembrandt created prodigious and highly personal works, as if painting only for himself without thinking of outside factors.

– *The Conspiracy of Julius Civilis* (1661, National Museum, Stockholm), an unusual painting in which Rembrandt reaches new heights in his technique of primers and layers.

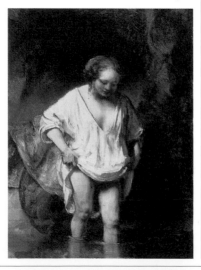

Rembrandt. Woman Bathing (Hendrickje) (1655). Oil on canvas, 18³/₈ × 24¹/₈". National Gallery, London. In this small painting, the pictorial treatment is surprisingly modern, with layers of light colors applied with a truly genial precision.

*Rembrandt. Bathsheba (1654).
Oil on canvas, 55-3/8 × 55-3/8".
Louvre, Paris. The artist presents a
view of this biblical figure that is
very much in line with Baroque
Realism, and pictorially, a nude
of extraordinary quality.*

– *The Syndics of the Drapers'
Guild* (1662, Rijksmuseum,
Amsterdam). This group portrait
is a lesson in compositional skill
and psychological penetration. It
approaches the solidity of works
from his years of splendor rather
than the introspection of his last
aesthetic period.

– *Laughing Self-Portrait* (1665–
1668, Wallraf-Richartz Museum,
Cologne), moving for the pathos
created by the generous impasto
in the face of an elderly man still
able to face the world with
friendly sarcasm.

– *Portrait of a Lady with an
Ostrich Feather* (1660, National
Gallery of Art, Washington, D.C.).

This was one of his last paintings,
for Hendrickje's death slowed
his production.

THE ARTIST'S LIFE

1606. Rembrandt is born in
Leiden, the eighth son of a
rich miller.

1620–1624. He enters the
University of Leiden but
stays only a short time. He
begins to work as
apprentice to Jacob van
Swanenburg (1571–1638)
and soon afterwards
studies for six months
under Pieter Lastman of
Amsterdam. He predicts
"Rembrandt will only have
one master, and that is
nature."

1627. He meets a collector from
the Hague, Maurice Huygens.
His *Saint Paul in Prison* is
sold for 100 florins. He also
paints Huygen's portrait,
which represents his
successful establishment
as a painter.

1631–1642. Rembrandt moves to
Amsterdam and in 1634
marries Saskia van Uylen-
burgh, a rich woman with
whom he lives the eight
happiest years of his life
although they are fraught
with sorrow and economic
hardship. From 1635 to

1638, his first three children
die. Only his fourth child
survives, named Titus after
Titia, the nickname he
called his wife by. During
this time he paints some of
his most famous works,
and his wife appears
repeatedly in oil paintings
and engravings. Also at this
time, he produces his most
renowned self-portraits in
which he interprets the
atmosphere reflected in the
mirror as no one else can.
Some mythological paint-
ings are also carried out and
in 1642 he paints his most
famous painting of all—the
falsely named *Night Watch*.

1642. A tragically important year in
Rembrandt's life, his wife
Saskia dies at the age of
thirty.

1648–1660. These are his years of
full artistic maturity. His
period of great popularity as
a portraitist over, his
finances take a sour turn.
During this difficult time, his
young servant Hendrickje
Stoffels remains his unfail-
ing companion. She bears

their only child in 1654. The
baby girl is named Cornelia
after Rembrandt's first
daughter with Saskia, still
present in the artist's
memory. In the fifties,
although he is bankrupt,
Rembrandt's genius emerges
with renewed force and an
extremely personal style.
He reaches the crest of his
aesthetic ideals, sprinkled
with an evident sentiment-
ality, fueled by the conscious-
ness of his loneliness, and
by a fervent desire to
explore the deepest realms
of the human psyche.

1668. His son Titus dies only six
months after his marriage
to his cousin Magdalena
just as his financial situation
was taking a turn for the
better.

1669. On October 8, eleven months
after his son Titus's death,
Rembrandt passes away,
the greatest painter of all
Dutch masters, or for that
matter, of all time.

DUTCH INTERIORS:
JAN VERMEER

Interiors are one of the great achievements of seventeenth-century Dutch art.
They authentically reflect the intimacy of the home in a bourgeois society
of merchants. This genre managed to remain down to earth and
respect tradition despite outside influences.

General Characteristics

The Dutch masters, with Vermeer playing the lead role, portray homes that are solemn, orderly, clean, and particularly impregnated with a diffuse light characteristic of the Netherlands. Although Vermeer is the undisputed master of this genre, other artists, such as Pieter de Hooch (or De Hoogh, 1629–1683) and Gabriel Metsu (1646–1667) contributed certain innovations —a back light effect, diffuse halos of light and color highlights, which are the precursors of 19th-century styles.

The Painting of Jan Vermeer

Jan Vermeer, also known as Vermeer of Delft, was the "aristocrat" of Dutch interiors, with a technique that he purified, beginning in 1660, until it reached an extraordinary precision. His primers were highly personal, consisting of applying a sealer onto the canvas

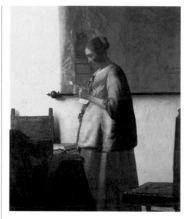

Jan Vermeer. Woman in Blue Reading a Letter (1665). Oil on canvas, 15¼ × 18⅛". Rijksmuseum, Amsterdam. One of the cleanest interiors with a figure among the many painted by Vermeer, after he had reached the height of his technique. His mastery in contrasting complementary colors is evident in the play between shades of yellow, blue, and green.

and then various layers of an earthy gray prepared from plaster, lead white, burnt umber, and coal black emulsified with oil and sealer. First the matte colors were added to the primer, working from lighter to darker shades to reach a chiaroscuro without impasto, using successive layers of color. This was a slow process culminating in the magic final touch of the highlights, achieved with lead white or yellow. The diversity of textures suggested through Vermeer's technique is fascinating.

Vermeer is a meticulous realist who eliminates all traces of tenebrism to allow natural light from a side door or window to flood the entire canvas. Located in the middle ground, the human figure not only receives the light, but also forms part of the luminous atmosphere and helps to create it. In Vermeer's interiors, the natural

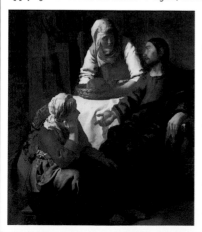

Jan Vermeer. Christ in the House of Mary and Martha. Oil on canvas, 63 × 56". National Gallery of Scotland, Edinburgh. With this early work, in which the figures appear in life size, Vermeer seems to be a "regular" Baroque painter embracing the vigorous chiaroscuro of the Utrecht tenebrists.

Jan Vermeer. The Lacemaker (1669–1670). Oil on canvas, 9¹³⁄₃₂ × 8¹⁄₁₆". Louvre, Paris. One of the best examples of his intimate style.

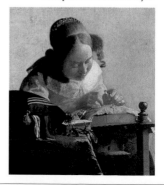

light, sometimes with silver highlights, realistically reveals moments of daily life in scenes of warm tranquility. Everything was meticulously prepared in his paintings, though they lack all sensation of theatrical staging.

Vermeer's work required a special technique, which conditioned the style.

Jan Vermeer. Kitchen-Maid (1658). Oil on canvas, $17^7/_8 \times 16$". Rijksmuseum, Amsterdam. The highly plastic character and exact detail lend a grandiose sensation to the figure and the still life which seems to belay the reduced dimensions of the canvas.

THE ARTIST'S LIFE

1632. Jan Vermeer is born in the city of Delft, son of Reyner Vermeer and Digna Baltens.

1647. He becomes an apprentice in the studio of Karel Fabritius (1622–1654), a painter of refined light effects who was also Rembrandt's teacher. His contract is valid for six years.

1653. On April 5 he marries Catharina Bolnes and at the end of the year is accepted to his city's painters' guild. He is later named trustee of the guild from 1662–1663 and 1670–1671.

1655. As a master painter, he begins his first creative period, to last five years. His first professional paintings are influenced by the Utrecht tenebrists as well as by his master Fabritius, from whom he inherits a taste for light effects. The first painting he signs is *The Procuress*, from 1656. It shows the Baroque style of his time, of strong tones and sharp chiaroscuro, characteristics also present in *Christ at the Home of Mary and Martha* (a large composition with life size figures, hanging in the National Gallery of Scotland,

Edinburgh) as well as in *Diana and Her Companions* (Mauritshuis, The Hague). He also produces the extraordinary *View of Delft*, on view at the same museum in the Hague. But Vermeer's painting soon evolves toward a search for space and atmospheric light. In 1657, he paints *Officer and Laughing Girl* (Frick Collection, New York) and in 1658, *The Kitchen-Maid* (Rijksmuseum, Amsterdam), in which he defines the basic characteristics of his future work.

1660. From this point on, Vermeer's work progresses toward a refined technique and style, concepts intrinsic to his painting. Chromatism, the style he perfected during the last fifteen years of his life, gives priority to lemon yellow and azure in an infinity of hues. Slowly but without interruption, he produces masterpiece upon masterpiece of interior painting. *The Lacemaker* (Louvre, Paris), which is said to have been painted between 1669 and 1670, is a prodigy of color, perfectly capturing the gestures and facial expression of the artisan,

completely involved in her delicate labor. *Woman in Blue Reading a Letter*, from 1665 (Rijksmuseum), is a masterpiece of compositional balance and play between complementary colors, namely, the yellow background hues, the blue dress, and the very dark green of several chairs with leather seats and backrests. *The Music Lesson* (Windsor Castle), *Allegory of Painting*, or *The Painter and His Model Posing as Clio* (1670, Kunsthistorisches Museum, Vienna), *The Geographer* (1668, Frankfurt Museum) and many others are unique representations of daily life impregnated with light and truth.

1675. Vermeer dies in Delft at the age of 43, leaving eight young children and a scant production limited by the complexity of his technique, but of immense human and pictorial quality. According to modern research, he can be attributed with absolute certainty only forty paintings, of which only twenty-five are signed and only three dated.

GENRE PAINTING

Independently of its prestigious figures, Frans Hals and Jan Vermeer, Dutch genre painting was developed by a series of so-called "minor" masters who gave this type of painting its essential characteristics. The origins of this school must be sought a century earlier with Pieter Brueghel the Elder (1520–1569) and his school, Pieter Aertsen (1508–1575), and Joachim Beuchelaer (1520–1574).

Painters of Popular Scenes

In the seventeenth century, the Netherlands was a country without kings, princes or noblemen, and whose international commerce provided a notable degree of wealth. The Dutch proved to be excellent businessmen. They were able to make paintings a consumer product and, with the exception of portraits, a source of amusement as well. Bourgeois tastes turned toward picturesque scenes in which the figures seemed to be acting out a scene in a play, immobilized by the artist. This truly popular genre reached heights of quality never matched by other painting that we would today call "commercial."

Adriaen van Ostade

Among the disciples of Frans Hals can be found one of the most prolific artists of the new genre—

Adriaen van Ostade. Villagers in an Interior: The Skaters *(1650). Oil on panel, 13⁷/₈ × 17¹/₈". Rijksmuseum, Amsterdam. One of Adriaen van Ostade's most famous interiors, with all the necessary requirements to please Dutch tastes of that time.*

Adriaen van Ostade (1610–1685). The works of this profoundly Dutch artist reveal that he was not educated by traveling through Italy like the painters of previous era, but rather by observing the everyday live show

offered by his native city, Haarlem, which he hardly left during the 75 years of his life. He specialized in village scenes with landscapes and, above all, in tavern scenes, possibly influenced by his master, Frans Hals.

In his first period, in which he paints works such as *The Village Inn* (1635) and *The Painter in his Studio*, both in the Dresden Pinakothek, he uses cold colors, with the predominance of gray tones. In his second period, he attempts to imitate Rembrandt's colorism. A good example of this is *Tavern Scene* (Christie's, London).

Isaack van Ostade

Educated alongside his brother Adriaen, Isaack van Ostade (1621–1649) was an artist of enormous potential, which was cut short by his early death, occurring before he ever reached artistic maturity. His limited production included country scenes and landscapes,

Adriaen van Ostade. Carousing Peasants in an Interior *(circa 1635). Oil on oak panel, 14¹/₈ × 11¹/₄". Alte Pinakothek, Munich.*

which showed a great concern for problems of light. His most typical subject matter depicts diverse scenes occurring in front of a house or an inn. A magnificent example is *Rest at the Farmstead* (1648, Kunsthistorisches Museum, Vienna), a theme that brought fortune to other painters.

Jan Steen

This prolific painter was the most amusing of all Dutch painters, the true successor to Brueghel, and the greatest genre painter of the seventeenth century.

His temperament, which we would today call "subversive," allowed him to see and bring out the comic aspects of any situation, even when he painted reprobating works of dissolute society like the one against alcoholism in the Duke of Wellington's collection. His restless character and the eclecticism with which he viewed life explain the fact that, being a renowned painter, he nonetheless had no qualms about taking up beer vending and hostelry as well.

Steen chose a variety of themes, taking the same delight in painting a kermess in the countryside as the interior of a dark tavern. He could paint a street scene, such as *Skittle Players Outside an Inn* (1660–1663, National Gallery, London), just as well as the interior of a bourgeois home, like *The Festival of Saint Nicholas* (1667, Rijksmuseum, Amsterdam) or *The Village Alchemist*, shown in his sordid workplace (Wallace Collection, London), etc. A subject matter often repeated by Steen and highly appreciated by the Dutch was that of a doctor attending a female patient. The doctor seems bewildered as to the cause of the woman's distress, but the key lies in a small figurine of Eros: the woman is afflicted with "lovesickness." In some of these paintings, though, such as the one in the Munich Museum, the author is more explicit, adding a notice that reads, "Medicine is of little use against lovesickness."

Jan Steen. The Festival of Saint Nicholas *(1667). Oil on canvas, 27¹/₂ × 32". Rijksmuscum, Amsterdam. Steen's bourgeois interiors offer a great sense of intimate family life.*

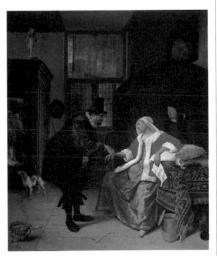

Jan Steen. The Lovesick Lady *(circa 1660). Oil on canvas, 20³/₈ × 23³/₄". Alte Pinakothek, Munich. The doctor finds nothing wrong—the small statue of Eros provides us the key to the enigma.*

THE ARTIST'S LIFE

1626. Jan Steen is born in Leiden, the son of a rich beer merchant. He shows his talent at drawing and painting early at the local Leiden school. In Haarlem he studies with Adriaen van Ostade, and in the Hague with the landscapist Jan van Goyen.

1648. By this time he is already on the list of guild members.

1649. He marries Margaretha, the daughter of van Goyen.

1657. He opens a beerhouse in Delft, which he runs at the same time as he is painting.

1661. After living in Leiden, he works in Haarlem for eight years.

1679. The year of his death, he leaves Haarlem to open an inn in Leiden and marry for a second time, to Maria van Egmont. Despite financial hardship, the painter managed to keep the inheritance his father had handed down to him and pass it on to his widow and children.

LANDSCAPE PAINTING

For many years, landscapes were consigned to a secondary role as backgrounds for religious paintings. These backgrounds, with their towns, cliffs, rivers, forests, and meadows, always a product of the imagination, can be considered the origins of Dutch landscape painting. Another precursor was the imaginary landscape, a free interpretation recreating "strange" places in faraway lands, with a certain romantic spirit.

THE GREAT ARTISTS WHO REVITALIZED EUROPEAN LANDSCAPE PAINTING

Jan van Goyen

Van Goyen was the first Dutch landscape artist to react against the random and false landscapes painted until then and produce a realistic landscape with his own style and colorism.

Jan van Goyen was born in Leiden in 1596 and died in the Hague in 1656. He was educated under second-rate masters until he began receiving lessons from Esaias van der Velde (1591–1630) in 1616. He achieved his personal style toward 1624: He converted each painting into a work of unified chromatism, with the predominance of warm gray tones verging on yellow, in which appeared a synthesis of the represented landscape. In this manner of painting, both clear skies and light mists are perfectly acceptable, often hovering over the waters of the Maas, a river seen in his most

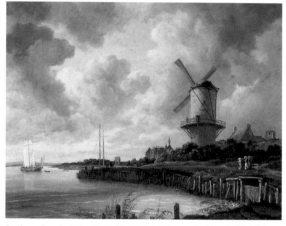

Jacob van Ruysdael. The Windmill at Wijk bij Duurstede *(circa 1670). Oil on canvas, 39³/₈ × 32³/₈". Rijksmuseum, Amsterdam. This may be the most reproduced Dutch landscape, appearing even in advertisements and other media.*

famous works. *View of the River* (Rijksmuseum, Amsterdam), *Seascape* (1644, Kunsthistorisches Museum, Vienna) and *View of Dordrecht* (1649, Louvre, Paris), with the Maas in the foreground, are characteristic paintings by van Goyen. Toward the end of his life, painted grandiose skies prac-

tically covering the entire canvas, as if expressing a desire to reach the sublime through them.

Jacob Isaac van Ruysdael

He has been called the Caravaggio of Dutch landscape painting. Just as the Italian painter affirms his Realism by accepting normal or even ugly subject matter for works of art, disassociting himself from the commonly held ideals of beauty, so van Ruysdael put aside interpretations of natural beauty and moved toward realism in landscape painting by emphasizing the most dynamic and dramatic aspects of nature—dark forests, stormy clouds, ruins, trees split by lightning, turbulent water, etc. After a first stage in which his favorite subject matter were the dunes and forests near Haarlem and Bentheio, the realism in van Ruysdael's landscapes evolved toward the clearly Romantic more than two centuries ahead of historical

Jan van Goyen. Landscape with Two Oaks *(1641). Oil on canvas, 43 × 34¹/₂". Rijksmuseum, Amsterdam.*

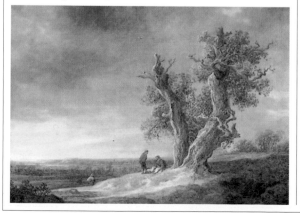

Romanticism. He was no longer an "imitator" of nature but rather an "interpreter" of what he saw, dramatizing a scene with low points of view and bold light effects to add contrast between the different grounds and highlight points of interest. These two aspects appear respectively in *Landscape with a Waterfall* (National Gallery, London) and *Bentheim Castle* (Rijksmuseum, Amsterdam).

Born in Haarlem around 1628, he worked with his father, Isaac van Ruysdael. It is surmised that he had other teachers, but he was mainly self-taught. In 1648, he had already been accepted by the guild in Haarlem, and in 1657, by the one in Amsterdam, where he received the right of citizenship in 1659 and produced the majority of his numerous works. Toward the end of his life, he was forced to return to his native city and died in the hospital there on March 14, 1682.

Meyndert Hobbema

He was born in 1638, probably in Amsterdam. Little is known of his education as a painter (he may have been a pupil of van Ruysdael) or of his difficult life. Unappreciated by his contemporaries, he occupied a low civil servant's post to which he was appointed thanks to his wife, a servant of the Amsterdam mayor. He and his wife (they died in 1709 and 1714, respectively) were buried as destitute people.

At the end of the 18th century, landscape painters, especially in

Hobbema is considered the true prophet of modern landscape Realism.

England, became more adept at Realism so that Hobbema's works began to be sought out and acquired great prestige.

He was thought to be the author of about two hundred pieces, of which two are particularly noteworthy for their great popularity today: *The Avenue, Middelharnis* (1689, National

Meyndert Hobbema. The Avenue, Middelharnis (1689). Oil on canvas, 55 × 40³/₈". National Gallery, London. The symmetry of this landscape lends it what could be called a special "visual naturalness."

Gallery, London) and *The Mill* (Louvre, Paris). In these works it is evident that Hobbema's Realism, though it well depicts the staid reality of Dutch landscape, also allows for the originality of composition and picturesque motifs so dear to Italianizing landscape painters.

Jan van der Heyden

Dutch 17th-century landscapes comes to a close with a brief reference to Jan van der Heyden, who was born in Gorinchem in 1637 and died in Amsterdam in

1712. Just as van Goyen, van Ruysdael, and Hobbema paved the way for Realism in landscape painting in general, van der Heyden was an innovator in the urban landscape. He left behind invented architecture and fantasy urban landscapes inspired by an imagined rather than a concrete Italy, and chose to paint views of the cities in his own country, especially of Amsterdam, anticipating the Italian *vedutti* painters not only in subject matter but also in the precision of the outlines, his grasp of perspective, and mastery of light effects.

Jan van der Heyden. Façade of the New Town Hall of Amsterdam (1668). Oil on canvas, 33¹/₂ × 28¹/₂". Louvre, Paris. Van der Heyden is the great Dutch specialist in urban landscapes.

THE STILL LIFE

Still life had never been as popular a genre and shown as much variety as in the Netherlands during the Baroque era. The seventeenth century is the Dutch Golden Age for this genre. It evolved from representations of everyday objects and bourgeois foods into the extremely showy "luxurious" compositions in which gold and silver objects from Lutma, porcelain from Satsuma, majolica from Delft, and Venetian glass are mixed in with exotic foods. Quality specialists in this genre were numerous. Since it is impossible to mention them all here, we shall limit the list to several painters whom we consider representative.

Great Specialists of Still Life

The popularity of the still-life genre in the Netherlands, and the detail used in each work must be seen in the context of science at the time. Already by the end of the sixteenth century, botany had become the science in vogue, and not only at universities. Collecting, classifying, drying, and knowing all about plants in general became such a widespread hobby that it gave a tremendous impetus to "fruit-and-flower-" type painting. Since the prospective buyer might be knowledgeable on plants, painters were forced to create not only beautiful paintings, but also ones of nearly documentary scientific quality.

Jan Davidsz. de Heem

Son of David the Elder, he was born in Utrecht in 1606 and died in Antwerp in 1684. He was one of those realist still-life painters of the time who were masters at producing portrayals of almost tactile quality, showing clearly the textures of porcelain and ceramics, cloth and metal, food of all kinds, etc. This genre is based on meticulous detail. All elements of the painting (composition, line, light, and color) are used to achieve a spectacular realism that surprises and captivates the viewer. The complex compositions of Jan Davidsz. de Heem, filled with diverse items, give the viewer a sense of complete disorder when they are

Davidsz. De Heem. Table with Dessert *(1640). Oil on canvas, 79 1/2 × 58 1/8". Louvre, Paris. This is one of the masterpieces of large compositions with diverse objects and foods.*

in reality the result of extremely precise calculations of the placement of each element. Perhaps the painting that best represents the artist's aesthetic is *Still Life with Dessert*, exhibited in the Louvre (Paris).

Gabriel Metsu

Textural painting was so highly valued in the still-life genre that some Dutch artists even specialized in painting fowl, for painting feathers is much more demanding than fur, requiring greater technical mastery and visual skill on the part of the painter. It is impossible to portray featherlike qualities by using meticulous detail work alone. This must be achieved through a synthesis which visually suggests these qualities.

Gabriel Metsu. Dead Rooster. *Oil on canvas, 15 5/8 × 22 1/4". The Prado, Madrid. The artist offers an excellent example of his pictorial technique in the successful portrayal of the texture of the feathers.*

Gabriel Metsu was born in Leiden in 1621. He worked in Amsterdam as a painter of interiors along the lines of Vermeer, and of genre paintings influenced by Rembrandt. Although he painted few still lifes, works like his *Dead Rooster* demonstrate that he was a great specialist in painting fowl. Few others were able to suggest the warmth and tactile subtleties of feathers like he did.

Gabriel Metsu passed away in Amsterdam in 1667.

Willem Claesz. Heda

This still life specialist is one of the creators of the "luxurious" model within the genre. He specialized in painting metal and glass objects accompanied by some plant elements, adopting a style designed to emphasize the precious qualities of shiny or transparent materials which he placed in front of plain backgrounds in simple compositions. He used colors which generally produced cold and grayish tones.

The "line" begun by Willem Claesz. Heda was initially followed by his son Gerrit (approximately 1620–1702) and profusely developed by other painters.

Rachel Ruysch

Some of the disciples of Willem van Aelst became famous painters.

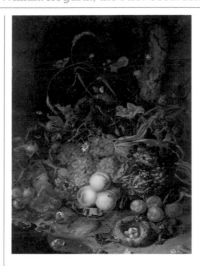

Rachel Ruysch. Flowers, Fruit, and Insects. Oil on canvas. Pitti Gallery, Florence. This painting is a lovely example of compositional mastery and of excellent use of light and color. But even more admirable is the precision, both botanically and zoologically correct, with which the painter details each and every element of the composition, studying them with the scientific rigor required to produce a technical illustration.

Of all of these, the most remarkable was a woman named Rachel Ruysch, a great specialist in flowers. She was born and died in Amsterdam, and her paintings were held in such high esteem in her time that their popularity far surpassed Rembrandt's. *Flowers, Fruit, and Insects*, in the Pitti Gallery in Florence, is one of the most highly regarded and most often reproduced flower paintings ever.

Willem Kalf

A Rotterdam painter, Willem Kalf (1622–1693) is another of the great Dutch specialists in interpreting material qualities. In his grandiose compositions, the porcelain, precious metals, Venetian glass, and luxurious cloth materials, cleverly illuminated, glitter with a light of their own, or are suggested by the reflections coming forth from somewhere in the darkness of the background. In the artist's ample creation, though, not all is showy luxury, since he also painted vegetables and kitchen interiors, in which the influence of Rembrandt can be seen.

Willem Claesz. Heda. Still Life (1642). Oil on canvas, 60³/₄ × 22⁷/₈". Rijksmuseum, Amsterdam. The gleam of metal and glass objects are a fundamental part of this work.

Willem Kalf. Still Life with Silver Vases. Oil on canvas. Rijksmuseum, Amsterdam.

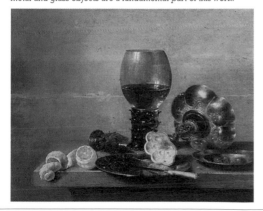

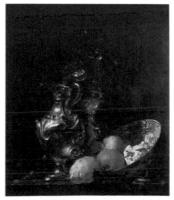

WILLIAM HOGARTH, THE FIRST GREAT BRITISH PAINTER

In Britain the artistic panorama had been dominated by foreigners since the Renaissance. Van Dyck's enormous production under Charles I did not serve as a precedent to younger English painters either. The Flemish genius left a pictorial void from which England did not begin to emerge with a style of painting truly its own until the beginning of the eighteenth century.

William Hogarth

Disassociated from all tradition and orthodoxy, grandson of a family of farmers, son of a school-teacher, unsuccessful writer and innkeeper, Hogarth initiated the great era of English painting. He came into contact with the arts of drawing and painting when, at the age of fifteen, the necessity of working led him to take up an engraving apprenticeship in a silversmith's studio, a position to which he was admitted because he enjoyed drawing and was not required to have other skills. With Hogarth, it is useless to search for influences that may have been acquired through studies or family tradition. In fact, when he began attending classes in 1718 at the Academy of Saint Martin's Lane, he ended up feeling true hatred for academic methods. In reference to these he wrote:

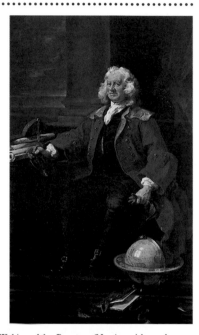

William Hogarth. Captain Thomas Coram (1740). Oil on canvas, 57 1/2 × 93 1/4". Foundling Hospital, London. As a portraitist, Hogarth connected with the van Dyck School and paved the way for what would become the great British tradition of portraiture during the eighteenth and nineteenth centuries, represented by such names as Reynolds, Gainsborough, Romney, and Hoppner.

"Even the most original spirit, if it were to adopt such [academic] methods would innoculate itself with other people's styles and would lose all ability to put anything at all personal onto the canvas."

Part of Hogarth's work is a continuous attempt at a critical and ironic approximation of English people's lives. He painted interior "scenarios" in which the characters have all been captured in a specific moment, acting out their individual roles to create a painting of local customs "fixed in the retina of my memory"—to use the painter's own words—thanks to skillful observation.

William Hogarth. The Waking of the Countess (Marriage à la mode, Scene IV), circa 1743. Oil on canvas, 35 1/2 × 27 1/2". Tate Gallery, London. This is an authentic description of English high society customs, clearly critical in content.

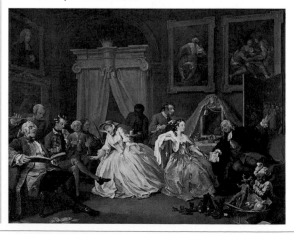

The other type of artwork he produced, the portrait, linked the English tradition starting with van Dyck to 18th-century English portraiture, a stage that he initiated.

William Hogarth. The Shrimp Girl (1750). Oil on canvas, 19⁷/₈ × 24³/₄". National Gallery, London. Sometimes in the history of art, works are produced that are ahead of their time.

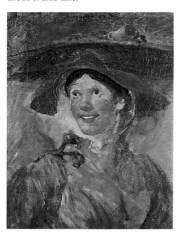

He created simple paintings with compositional formulas and fresh colors, an impasto of wide, fluid, and gestural brushstrokes that refused to stay within contours. His art was without Classicist pretensions nor attempts at eloquence that sought the essence of a gaze in its deepest recesses.

"Instead of overloading my memory with antiquated rules and ruining my eyesight copying dried-out and deteriorated paintings, I have always believed that copying Nature was the most direct and certain way to acquire a greater knowledge of my art."

William Hogarth. The Hogarth's Servants (1750–1755). Oil on canvas, 29⁵/₈ × 24¹/₈". National Gallery, London. A set of faces portrayed with a profound respect for the people whom the painter had at his service.

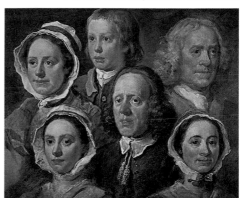

THE ARTIST'S LIFE

1697. Hogarth is born in London on November 10. His father, Peter Hogarth, a schoolteacher and sporadic Latinist writer, had opened a guesthouse in the popular neighborhood of Old Baily. His problems with the Treasury and his father's failures lead him to scorn Classical studies.

1712. He begins working as an engraver's apprentice in the silversmith Ellis Gamble's workshop.

1718. He attends classes at Saint Martin's Lane Academy.

1720. He becomes an engraver of commercial badges and emblems. His first work dates from April 23, a card with some cupids, signed "W. Hogarth, engraver."

1724. Attends classes by James Thornhill at the Liberal Academy.

1726. He makes his work public through illustrations for Butler's *Hudibras*.

1728. He begins to develop his painting.

1729. He sequesters his teacher's daughter and marries her. There is consequently a quarrel with his irate father-in-law.

1734. His father-in-law dies and he succeeds him as director of the drawing school.

1743–1745. He paints six satirical scenes in the series *Un Marriage à la Mode (A Fashionable Wedding)* (Tate Gallery, London), his most characteristic satirical interiors. Some of his other portrayals of traditional scenes are: *Old England's Roast Beef* (Tate Gallery, London), *The Story of a Libertine* (Rake's Progress), *A Choice* (Sir John Soane's Museum, London) and the theatrical scenery in *The Beggar's Opera* (Tate Gallery, London).

1753. He publishes his *Analysis of Beauty*, a vague treatise on aesthetics in which he defends freedom and movement in art, and disqualifies all rigidity and academicism.

1750. He paints one of his most typical works, *The Shrimp Girl* (National Gallery, London), an impressive portrait with a somewhat impressionistic air of a vivacious and smiling young woman surprised at the moment of turning her head.

Hogarth produces portraits of great beauty such as his *Portrait of Captain Thomas Coram* (Foundling Hospital, London) or *The Hogarth's Servants*, a superb study with six portraits.

1757. He is appointed Sergeant Painter to George III.

1764. He dies in Chiswick on October 25 or 26, after several years of illness and political disputes.

SIR JOSHUA REYNOLDS

Reynolds is the next great British painter of the eighteenth century after Hogarth.
To summarize, Reynolds combined Venetian colorism, which he assimilated
during his visits to Italy, with the freshness of Hogarth's work.

The Painting of Sir Joshua Reynolds

An educated man, his very education made him a person of eclectic tastes. He admired Baroque and Renaissance art alike, and at the same time was impressed by the idealized subtlety of Gothic art.

The artist's contact with the Renaissance lent his art an Italianizing quality of warm hues and compositions of calculated harmony. His admiration for Italian art led him to appreciate historical paintings, even considering them a superior genre. Nevertheless, the genre that placed Reynolds among the great painters of

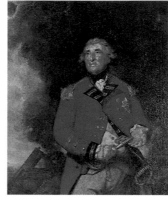

Reynolds. Lord Heathfield, Governor of Gibraltar (1787). Oil on canvas, 43 1/4 × 55 3/8". National Gallery, London.

history is portraiture. As a portrait artist, he allowed his sitters full freedom to pose as they wished so that they would reveal some aspect of their inner psychology.

Reynolds was one of those artists who arrived at his style through his own technique, so that the development of the former was a direct consequence of the improvement of the latter.

He painted on light canvases with a white or gray primer. After carrying out preliminary drawings, he marked the location of the sitter's head, always placed near the center of the canvas, with a touch of white paint. On top of this, he outlined

Reynolds. Commodore August Keppel (1752). Oil on canvas, 53 3/8 × 93 1/8". National Maritime Museum, Greenwich, England.

Reynolds. Lady Jane Holliday (1779). Oil on canvas, 55 3/8 × 44 1/4". The National Trust, Waddesdon Manor. A precursor of English Romanticism.

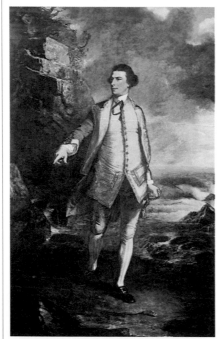

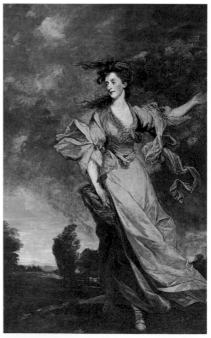

the general facial features in white and black lacquer, working with wet layers, until the faces reached a deliberate paleness. Slowly, as he enjoyed working, he would begin to apply the lighter opaque colors (Naples yellow as a base for flesh colors) and then, in successive sessions, subtle layers of warm colors that never canceled out the underlying ones. When the face was done, his assistants would come into action: one would paint the clothing, with the help of a mannequin, while the other did the background, if there was one. Finally, Reynolds himself would touch up the light and add the shines and finishing touches.

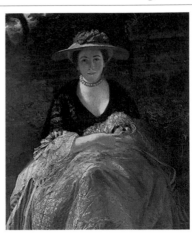

Reynolds. Nelly O'Brien (1760–1763). Oil on canvas, 49³/₄ × 39³/₈". Wallace Collection, London. This portrait alone places Reynolds among the most eminent portraitists of all of history. The shadows on the woman's face and chest show a prodigious mastery of color and justify, in and of themselves, the frontality of the portrait.

THE ARTIST'S LIFE

1723. Sir Joshua Reynolds is born in Plympton, St. Maurice, to a distinguished Devonshire family. His father, the Reverend Samuel Reynolds, had studied at Oxford and was director of the local primary school.

1740. Taken by Jonathan Richardson's *Treatise on Painting*, he decides to go to London and study for three years under the portrait artist Thomas Hudson. He returns to his native town, where he stays for six years painting portraits and an occasional landscape.

1749. He meets Commodore Augustus Keppel. They become good friends and travel together through Europe. In Rome he studies the works of Michelangelo and Raphael, in Florence he sees the paintings of Massacio for the first time, and in Venice he is completely overwhelmed by Titian.

1752. After returning to Britain, he settles definitively in London, where he frequents intellectual and political circles. He paints his first portrait, *Commodore Augustus Keppel* (National Maritime Museum, Greenwich), after which his success is

continuous, and his paintings are sought after.

1753–1768. In his first period, he perfects his style, taking better advantage of the influences received from Italian painters, as well as Rembrandt and van Dyck. He paints portraits of great beauty, in which his masterful technique captures a genuinely British elegance: *Portrait of Mrs. Hoare and her Son* (Wallace Collection, London), *Lady Elizabeth Hamilton* (1758, National Gallery of Art, Washington, D.C.) and two of his most beautiful portraits, *Lady Bamfylde* and Mrs. Braddyll (Wallace Collection). His *Portrait of Nelly O'Brien* (1763, Wallace Collection), a famous courtesan of the time, is most interesting for the bold frontal view, the exquisitely rendered flesh colors, the soft shadows shed by the sitter's hat, and the treatment of the dress. These elements make it one of the best paintings of the eighteenth century.

1768. King Charles III appoints him president of the recently created Royal Academy. The honorary titles are not long in coming.

1769. He is given the title of Sir, and in 1773, the honorary degree of Doctor from Oxford University. In 1784, he is appointed painter to the king.

1768. Reynolds enters his second and last artistic period. He relies on what he considers should be the "law of chiaroscuro" (i.e. 1/4 light, 1/4 dark, and 2/4 in between). He perfects his personal technique. His portraits become fuller, with a firmer modelling and more lyricism. His portrait of *Lady Jane Holliday* (1779, National Trust, Waddesdon Manor) has a tempestuous background that announces the arrival of Romanticism. In 1787, he paints *Lord Heathfield, Governor of Gibraltar* (National Gallery, London) and in 1780, a *Self-Portrait* (Royal Academy of Art, London).

1791. He dies in London, blind and paralyzed. Before he dies, he hears the Russian Empress's critique (1788) of his paintings *The Shakespeare Gallery* and *Hercules as a Child*. He is buried with great pomp in Saint Paul's Cathedral.

THOMAS GAINSBOROUGH, PORTRAIT AND LANDSCAPE ARTIST

In 1719 and 1720, Watteau was working in Britain. His art was highly appreciated by the artists of that country, who felt attracted by Rococo. For instance, the painter and engraver Hubert François Bourguignon, known as Gravelot (1699–1773), and artists such as the Scotsman Allan Ramsay (1713–1784), court painter under George III and writer, cultivated the delicacy, the elegance, the satiny lights and dreamy landscapes typical of Watteau. The most interesting of the artwork influenced by Watteau was doubtless that of Thomas Gainsborough.

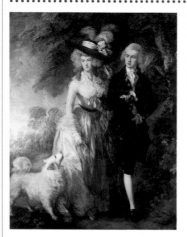

Thomas Gainsborough.
Morning Promenade *(1785).*
Oil on canvas, 69³/₈ × 90⁷/₈".
National Gallery, London.
A married couple of high British society, pictorially represented with a clear atmosphere of Preromanticism.

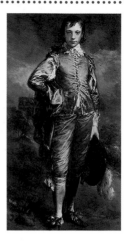

Thomas Gainsborough.
The Boy in Blue, *detail (circa 1770). Oil on canvas, 47¹/₂ × 69³/₈". Henry E. Huntington Library and Art Gallery, San Marino, California. One of Gainsborough's most typical works, with the sweeping brushstrokes to which Reynolds attributed the beauty of his paintings.*

The Artwork of Thomas Gainsborough

A disciple of Gravelot and influenced by Watteau, he added elements coming from the other side of the Channel to a British sensibility. He brought British portraiture to a degree of lyrism never before reached.

Gainsborough was also one of the most important landscape artists of the 18th century, the one who introduced the ideas that have developed into the precepts of the modern Realist landscape, without theatrical or mythological caprices. There are no Roman ruins, nor is there any trace of nymphs, fauns, and other specimens of Classicism that, even in his time, were often considered the only justification for painting a landscape at all. Gainsborough cultivated his Realism, and he did so in specific places at different hours of the day, in Cornard Forest (today known as Gainsborough Forest) and in Ipswich, whose views are at the origin of British seascapes.

Thomas Gainsborough. The Harvest Wagon *(1767). Oil on canvas, 56³/₈ × 46⁷/₈". Barber Institute of Fine Arts, Birmingham, England.*

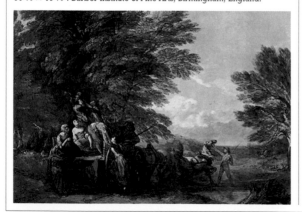

"His landscape is delicate yet exciting. The immobility of midday, the profundity of dusk, the dewdrops in the morning, all of this is present in the canvases of this kind-hearted, affable person."

John Constable

Although circumstances led him to become an enormously successful portrait artist, he would have preferred to return to his true "pictorial love"—the landscape. His pictorial technique as a mature artist was aptly described by Reynolds's words on the spontaneity of his brushstroke:

"The sweeping brushstrokes and strange signs so visible in Gainsborough's paintings when examined from up close . . . those repellent and amorphous aspects . . . take shape as if by magic when seen from a distance. We must conclude that those cutting and apparently haphazard touches are the essence of the fresh beauty of Gainsborough's works."

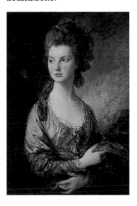

Thomas Gainsborough. Mrs. Graham *(1775–1777). Oil on canvas, 26⁷/₈ × 34⁷/₈". National Gallery of Art, Washington, D.C. A demonstration of his ability to capture the beauty of a female face.*

Thomas Gainsborough. Mrs. Sara Siddons *(1785). Oil on canvas, 39 × 48³/₄". National Gallery, London. This painting of great formal and chromatic beauty was done three years before the death of the artist.*

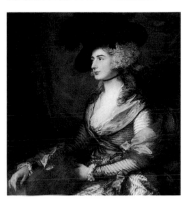

THE ARTIST'S LIFE

1727. He is born in Sudbury, son of a cloth merchant and youngest of nine siblings. Perhaps influenced by his mother, who was an avid flower painter, he begins to paint landscapes from nature at twelve years of age.

1740. His father decides to send him to London, where he studies under Hubert Gravelot who instills in him a taste for Watteau's aesthetic. Toward 1744, after four years of practicing portraiture and landscapes, he returns to Sudbury. Here he meets and marries Margaret Burr, the illegitimate daughter of the Duke of Beaufort.

1746. The young couple—she is seventeen when they marry—settles in Ipswich, and the 200 pounds from Margaret's annuities allow them to live an easy life. He is able to dedicate himself to his great passion—landscape painting. During his twelve years in Ipswich, Gainsborough's landscapes ac-

quire a realism of light, and he establishes the basis of British seascape painting. *Mr. and Mrs. Andrews* (1750, National Gallery, London) dates from this first period. In this somewhat ingenuous painting, the figures are placed in an open landscape.

1758. To obtain a wider public, Gainsborough moves to Bath, a fashionable spa at the time, and dedicates himself to portraiture. His success is complete: he starts off charging five guineas for a bust portrait and ends up charging one hundred for a full body portrait. He paints his well-known canvas *The Daughters of the Painter Chasing a Butterfly* (National Gallery, London) in 1759.

1766. He becomes a member of the Artist's Society.

1768. He is cofounder of the Royal Academy. In 1770, he paints his celebrated work, *The Boy in Blue* (Henry E. Huntington Library and Art Gallery, San Marino, California).

1774. He settles in London, becoming the king's favorite painter, of whom he eventually paints eight portraits. In his last period in London, he paints such significant works as *Mrs. Graham* (1775–1777, National Gallery of Art, Washington, D.C.), *Mrs. Sara Siddons* (1785, National Gallery, London), *The Morning Walk* (1785, National Gallery, London) and *On the Way to the Market* (1785, Tate Gallery, London), one of his most famous landscapes.

1783. He feels that his paintings have been badly placed at the annual academic exhibit and he begins to hold himself aloof from Reynolds.

1788. He dies in London after making amends with his friend. It is said that, shortly before dying of cancer, he told Reynolds, "We will see each other in heaven, and van Dyck will be there too."

GEORGE ROMNEY AND JOHN HOPPNER

Hogarth, Reynolds, and Gainsborough are the great creators of British portraiture (and landscape), and it could even be said that they mark the character of all British painting in the eighteenth century. British painters after them follow the norms they established and, to a certain extent, add to them. After the aforementioned triad, the eighteenth century brought no great geniuses or innovators to British painting, but there were several excellent painters. Particularly distinguished were Romney and Hoppner, a portraitist who was as renowned as Reynolds in his time, and whose works are closely related.

George Romney, Lady Hamilton's Painter

Of all the painting related to Reynolds' work, Romney's came the closest to a continental style, with constructive (but not fine) lines which led to forms with highly plastic shading of marked sculptural intent. Nonetheless, Romney camouflaged these academic traits through light brushstrokes, a fluid dynamism in the poses used, and the freshness of the backgrounds, of very British taste. Romney soon specialized in painting children and ladies of British high society. Two examples of his works with these themes are *Mother with her Child* and *The Levenson-Gower Children*, both in London. But his voluptuous style seems reserved for portraits of his model of predilection, Emma Hart (or Lyon), later Lady Hamilton. She was an exceptional woman who rose from tavern singer to Nelson's lover. She later became friends with Queen Carolina of Naples, and finally married the British ambassador to that city, Lord Hamilton. *The Muse*, as Romney called her, was the inspiration for his best and most "sensitive" paintings. The future Lady Hamilton appears seductive and coy in *The Shepardess* (Baron Rothschild Collection), sentimental in a praying position in *Portrait of Emma* (Audley Collection), exotic in *Oriental*, insinuatingly half nude in *Bacchanal*, maternal in *Alope*. She also modelled for allegorical paintings, always changing in her beauty. She is portrayed holding a dog or surrounded by flowers as *Nature* (Frick Collection, New York), and also as

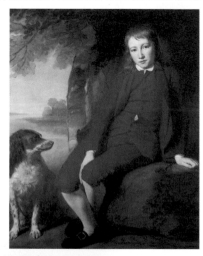

George Romney. Master Ward. Oil on canvas, 39³/₄ × 49¹/₈". The Prado, Madrid. His realist ideals lead Romney to paint his sitters in poses that appear instinctively natural.

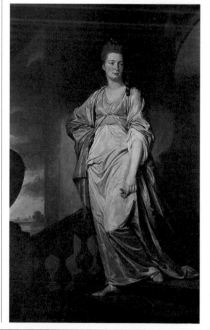

George Romney. Mrs. Verets (1773). Oil on canvas, 52⁵/₈ × 91⁵/₈". Private collection, Birmingham, England. This woman's image, not exempt of a certain voluptuousness and languid air, epitomizes the smooth formal and chromatic elegance of British portraiture during the last quarter of the eighteenth century.

Sensitivity, Contemplation, The Muse of Tragedy, and *The Muse of Comedy,* as well as such figures as *Circe, Cassandra, Ariadna, Saint Cecilia,* and many others.

Biographical Outline

George Romney was born in Dalton-in-Furness in 1734. Son of a cabinetmaker, he soon discovered his talent for wood-carving. In Dalton, he became an apprentice to Christopher Steel, an adventurous artist who called himself Count Steel.

He married Mary Abbott, the nurse who had cared for him during an illness. He was able to live off of his portrait painting with sound financial results. In 1762, at the age of twenty-eight, having saved an appreciable sum, he gave a third to his wife and left for London just when Reynolds and Gainsborough were at the height of their careers. He introduced himself to London artistic circles, let himself be known, and prepared a trip to Italy. He hoped he would become famous there. In 1775, after two years on the continent, he returned to London, where his renown grew to the point that even Reynolds became envious and barred his entry to the Royal Academy. In 1799, after having led an agreeable life with sufficient financial resources and

many friends, a paralysis forced him to retire to Kendal, where his once-abandoned wife took him in affectionately and cared for him until his death on November 15, 1802.

John Hoppner: A Flattering Portrait Artist

Hogarth, who knew his fellow citizens well, had predicted that portrait painting would always flourish in Britain because vanity was inherent in it. John Hoppner was just the sort of painter who understood this and who knew how to take advantage of this feature. Hoppner's portraits, mostly of women and children, are intended and carried out in such a way as to flatter the sitter. His method gained him popularity and clientele. In his attempt to please, he placed his artistic talent at the service of sentimentality, creating paintings somewhat similar to Guido Reni's overdone style. Hoppner would prepare especially beautiful standard faces which he tried to adapt to the actual features of the person being portrayed. He rarely achieved striking individuality, but these were pretexts for portraits, like that of his wife Phoebe Wright as *Sofia Western,* or the *Countess of Oxford* (National Gallery), considered his best work.

Hoppner was born in London in 1758. His parents were of German extraction. His father was Royal Surgeon at Saint James Palace, where John grew up. He was accepted into the royal chapel choir because of his beautiful voice, and received the patronage of George III, whose attention fed rumors that he was his bastard son. In 1789, he was appointed "Regular Painter to His Majesty" William IV and he was accepted into the Academy in 1795.

He died in 1816, having enjoyed great popularity in life.

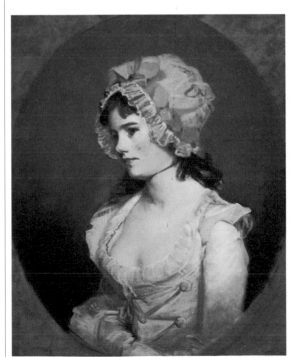

John Hoppner. Mrs. Williams. Oil on canvas, 23³/₄ × 28⁷/₈". Tate Gallery, London. The flattering character of Hoppner's portraits does not diminish his artistic merit, evident in the quality of the clothing and the soft skin colors of his figures. His efforts to please his sitters did not make him lose his sense of elegance, an inherent part of British portraiture since van Dyck.

GREAT WATERCOLOR PAINTERS

In no other country has watercolor painting enjoyed so much popularity. Indeed, it had become so popular in the period between 1750 to 1860 that many people on the island thought it had been a British invention. The movement which led to British Romanticism found in watercolor painting the pictorial medium that would support the research and experimentation carried out into new aesthetics and new concepts of painting. The great eighteenth-century watercolor painters—Paul Sandby, Alexander Cozens, John Robert Cozens, Thomas Girtin, and many others—lent British landscape painting the "modern" characteristics still present in today's watercolors.

Paul Sandby

From Surveyor to Landscape Artist

Paul Sandby was born in Nottingham in 1725 and died in London in 1809. He moved to London in 1741 with his brother Thomas, an architect and forest ranger working for the government, to become a surveyor for the military drawing office. Sandby is a typical example of how the topographers of the eighteenth century were the errant knights of watercolor landscape painting. His evolution toward pure landscape painting began in 1745 in Scotland. While describing the physical geography of the Highlands, he felt taken by the effects of light which he was using as a means to indicate uneven terrain, as well as by the various details that helped identify a specific place—a group of trees, a decrepit building, or a monastery. Artistic feeling and even an archeological interest began to override the practical purposes of

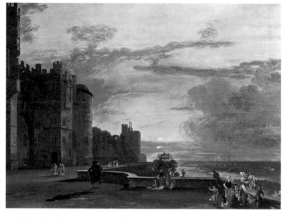

Paul Sandby. Windsor Castle—Terrace Seen from the Northeast. *Watercolor on panel, 24 × 18 1/8". Victoria and Albert Museum, London. Sandby not only reproduced a landscape, he also communicated to the viewer the mood suggested by an atmosphere.*

topographical painting, and Sandby's landscapes became a creative expression of a state of mind.

Technically speaking, Sandby could not be called an orthodox watercolor painter. Although he uses water as a medium and, occasionally, overlapping layers as well (in this sense he is a true watercolor artist), his whites are opaque and his surfaces not necessarily paper. One of his most famous paintings, *The Terrace of Windsor Castle*, a watercolor on panel at the Victoria and Albert Museum in London, seems to support those who compare Sandby with Canaletto.

Alexander Cozens

Alexander Cozens (1716 or 1717–1786) was probably the son of one of the naval engineers who accompanied Peter the

Alexander Cozens. Landscape with a Hill in Shadow. *Sepia ink wash, 11 1/2 × 8 5/8". Fitzwilliam Museum, Cambridge, England. A sketch of an imaginary landscape, technically similar to Oriental art, although it is not certain that Cozens was acquainted with it.*